IMAGES
of America

THE JAMES RIVER

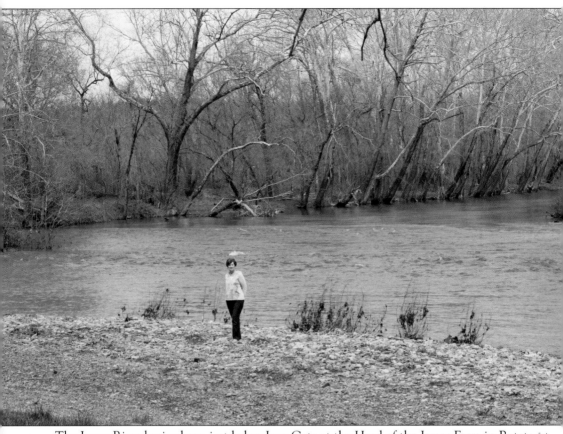

The James River begins here, just below Iron Gate at the Head of the James Farm in Botetourt County. The Jackson and Cowpasture Rivers join to form the 340-mile-long James, which flows to Hampton Roads and the Chesapeake Bay at Newport News. (Photograph by the author.)

ON THE COVER: The Chesapeake & Ohio Railway (C&O) piers at Newport News appear in the background of this view from a c. 1909 Detroit Publishing Company postcard. Two huge wood and sheet metal grain elevators, designated A and B, dominate the skyline. They were later burned in 1915 and 1934, respectively. A large schooner is at the pier, and the beautiful and beloved James River steamer *Pocahontas* glides past in the foreground. (Courtesy of the Library of Congress.)

IMAGES
of America

THE JAMES RIVER

William A. Fox

ARCADIA
PUBLISHING

Published by Arcadia Publishing
Charleston, South Carolina

Printed in the United States of America

Library of Congress Control Number: 2015943283

For all general information, please contact Arcadia Publishing:
Telephone 843-853-2070
Fax 843-853-0044
E-mail sales@arcadiapublishing.com
For customer service and orders:
Toll-Free 1-888-313-2665

Visit us on the Internet at www.arcadiapublishing.com

*This book is dedicated to my dear wife, Mary, who has explored
and enjoyed the James River with me over the past 38 years.
Her kindness, patience, and advice have enabled me to fulfill
a lifelong dream of writing a book about the James River.*

CONTENTS

ACKNOWLEDGMENTS

I was born a few hundred yards from the James River and have lived near it for almost all of my life. Like many others, I love the river, and I have now seen and experienced its entire 340-mile length to produce this book. Many excellent books about the James have preceded this one, but none have offered the visual wealth of 222 images included here.

My most useful references include Ann Woodlief's excellent *In River Time* (1985); journalist Earl Swift's *Journey on the James: Three Weeks through the Heart of Virginia* (2001); T. Gibson Hobbs's *The Canal on the James* (2009, compiled and published by Nancy Blackwell Marion four years after his death); and Dr. William E. Trout III's atlases, especially *The Upper James Atlas* (2001), *The James River Batteau Festival Trail* (2002), and *Falls of the James Atlas* (1995), which are full of history, images, and topographic maps that show every foot of the James in great detail.

I wish to thank Susan Connor, Adrin Snider, and the skilled photographers of the *Newport News Daily Press* for many of the images in this book. The Library of Congress Prints & Photographs Online Catalog provided excellent images, particularly from during the Civil War era. Dana Puga and Megan Townes at the Library of Virginia helped with images and permissions, as did Jennifer Anieleski and Erin Lopater at the Mariners' Museum. Eric Wilson of the Rockbridge County Historical Society steered me to Washington and Lee University's Leyburn Library, where Lisa McCown and Seth McCormick-Goodheart opened its collections for this book. Margaret Thomas of Historic Buckingham suggested images for that county, and Bill Geoghegan of Yogaville provided beautiful images of the structures there. At the Scottsville Museum, Connie Geary kindly provided images of the charming river town. Vicky Wheeler and Harry Gleason of Buchanan showed me the beautiful 1855 Beyer watercolor of their town and granted permission to reproduce it here. Nancy Marion provided images from the Jones Memorial Library collections in Lynchburg. Michael Dixon at the Chesapeake and Ohio Historical Society (COHS) provided images. Justin Doyle at the James River Association offered images and advice. My friends Bill Ewen, Kurt Reisweber, and Will Molineux contributed both images and editorial help. So did my new friends Dr. Bill Trout, Holt Messerly, and Philip deVos, of the Virginia Canals & Navigations Society (VCNS). Thanks go to Lisa and Paddy O'Sullivan, who "floated" me down the James from Slate River to Cartersville in their great batteau *Clifton Lee* on a warm day in June. I am also grateful to my contacts Lily Watkins, Gillian Nicol, and Tim Sumerel at Arcadia Publishing, to Bill Lee for his editorial help, and to Brenda Duckwall and Ron Hudik for helping with the maps. Thanks go to many others who helped with this book, especially to my wife, Mary, whose patience and love are boundless. All photographs are by the author unless noted otherwise.

INTRODUCTION

In 2007, House Resolution 16 of the 110th Congress named the James River as America's Founding River. The first permanent English settlement in the New World was made in 1607 on the banks of the James at Jamestown, and representative government in America began there in 1619. Later, canalboats, steamboats, and railroads made it a hub of commerce and communication for a growing Virginia. The James River flows for 340 miles, entirely in Virginia, from the Allegheny Mountains to Hampton Roads and the Chesapeake Bay. It passes the cities of Lynchburg, Richmond, Hopewell, and Newport News and the counties of Albemarle, Amherst, Appomattox, Bedford, Botetourt, Buckingham, Campbell, Charles City, Chesterfield, Cumberland, Fluvanna, Goochland, Henrico, Isle of Wight, James City, Nelson, Powhatan, Prince George, Rockbridge, and Surry along with many small towns on its way to the sea. All along the way, scenic beauty, wildlife, and history are found, and many of its landscape views are relatively unchanged since 1607.

Native Americans named the river Powhatan for the chief of the Powhatan Confederacy on the coastal plain, whereas the English settlers named it the James River, after King James I. Prior to the Civil War, the upper part of the river was named the Fluvanna, after Queen Anne. After 1865, it was all known as the James. During early days, the navigable lower part of the river below the fall line was the principal highway for shipping crops, especially tobacco. The Jamestown colony finally prospered after a difficult start, and rapid westward growth resulted. Sharp looping bends, or "curles," above present-day Hopewell prevented large vessels from reaching Richmond, so these were eventually cut off by dredging, creating islands and straightening the river for navigation. Today, small oceangoing ships can reach a deepwater port just below Richmond.

Above the fall line, goods were transported by shallow-draft small crafts known as batteaux, which were usually about 60 feet long and poled up and down the river. The Falls of the James at Richmond effectively prevented navigation between the upper and lower parts of the river. After the Revolutionary War, improvements were made to the upper James to make navigation safer. George Washington championed these efforts, and by 1791 the first operating canal system with locks in America was constructed around the falls from the west end into downtown Richmond.

In 1820, the James River Company was taken over by the Commonwealth of Virginia with the intent of building a canal to connect the James River with the Kanawha River via a turnpike across the mountains. During the 1820s, Virginia engineer Claudius Crozet extended the canal to 28 miles above Richmond and built a seven-mile canal through the Blue Ridge Gorge around the treacherous Balcony Falls. The largest engineering project of its time was begun in 1832 by the reorganized James River and Kanawha Company. It included construction of the canal, dams, and a towpath for horses and mules. The canal was completed to Lynchburg by 1840 and to the town of Buchanan by 1851. Traffic proliferated, and in 1854 there were reportedly 195 boats on the canal, including six packet boats for passengers. The canal west of Buchanan was never finished, and in 1880 it was sold to a railroad, which laid its tracks on the towpath. Many remnants of the canal survive today, and much of it has been restored in Richmond. The James

River line of CSX Transportation on the canal towpath now carries freight. Transporting over 25 million tons in 2014, it is the primary route for coal shipments from West Virginia to export piers at Newport News.

Cities and towns grew on the James in the 19th century. Richmond became a major manufacturing center, thanks to waterpower from the river, and fortunes were made on tobacco, flour milling, and coffee. According to historian Virginius Dabney, Richmond's population grew by 37 percent—from 27,000 to 38,000—in the 1850s. Chartered in 1786, Lynchburg became a major port for the shipment of tobacco, grain, and produce down the canal to Richmond. The James River and the canal played an important role during the Civil War. Troops and supplies moved on both, and the historic Battle of the Ironclads was fought at the mouth of the river off Newport News in March 1862. Tredegar Iron Works, on the river in Richmond, manufactured much of the iron and artillery for the Confederacy, and the Confederate Navy Yard was located at Rocketts, just below Richmond. Union forces moved up and across the James to City Point (present-day Hopewell) and built a major port and supply center there. They were unable to advance farther up the river due to heavy shore batteries, particularly the one at Drewry's Bluff, so they were not able to take Richmond before the surrender in April 1865. As the Confederate government fled and the city was abandoned, valuable tobacco warehouses along the river were set ablaze. The fire raged out of control and destroyed the waterfront and much of its industry. Richmond was in ruins.

Tredegar Iron Works was undamaged and continued helping to rebuild the South. Railroads were rebuilt, while the canal declined and was closed. Steamboats, first introduced on the lower James River in 1817, became commonplace. Scheduled passenger and freight service was offered from Richmond to Norfolk and to points in-between and north. Newport News was founded in 1881 and became a major shipbuilding center and port. Passenger traffic and steamboat service on the James ended around 1920 with the advent of the automobile. The city of Hopewell became an industrial center during World Wars I and II, manufacturing dynamite, guncotton, and then chemicals. Other major industry grew on the river, particularly above Lynchburg and between Richmond and Hopewell.

As Parke Rouse Jr. writes in the introduction to his 1990 book *The James: Where a Nation Began*, "After decades of pollution and defacement, the James shows signs of regaining its natural beauty." The river had become, in the eyes of many, an open sewer. Ann Woodlief recounts the beginnings of the river's recovery in her 1985 book *In River Time: The Way of the James*. After Rachel Carson's *Silent Spring* in 1960, there was an increased concern for the environment in the country and around the world. In 1970, the US Environmental Protection Agency was created, and the first Earth Day was celebrated on April 22 of that same year. Then, the Clean Water Act of 1972 gave governments the power to regulate urban and industrial wastes. As Woodlief writes, "fish life began rebounding as the river freed itself." And later, even the eagles started to return.

But then the worst happened. In 1975, Life Science Products in Hopewell was shut down by the Commonwealth of Virginia due to the human health impacts of Kepone, a toxic insecticide produced by the company. A few months later, Gov. Mills Godwin closed the James River to fishing. Because Kepone slowly breaks down in the environment, the fishing ban lasted for 13 years, devastating the river's fishing industry. The James River Association formed in 1976 to be a voice for the river and the people who care about it. The health of the river has improved thanks to the work of the James River Association, other organizations, agencies, and individuals. The James is now consistently graded as one of the healthier major tributaries of the Chesapeake Bay, and the river is a major recreation and tourist draw for the communities along it. The James River Association's 2013 State of the James River report gives the river a score of 53 percent or a grade of C. So, progress was made. And the river has become a great center for recreation all along its path, including the 7.5 miles of James River Park in Richmond.

The images and text on these pages explore the James River from 1607 to the present; enjoy a 340-mile journey from Iron Gate to Newport News. For reference, readers are encouraged to consult the maps in chapter 6.

One

THE BEGINNING

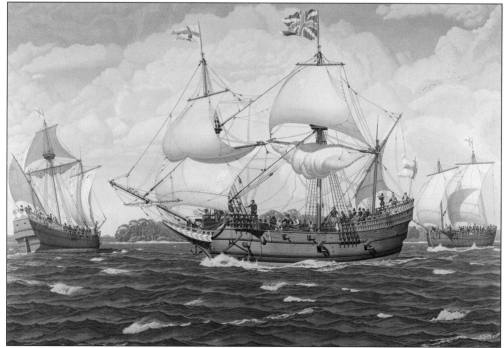

This painting by Comdr. Griffith Bailey Coale (1890–1950) depicts, from left to right, the *Godspeed*, *Susan Constant*, and *Discovery* arriving at the site of Jamestown with 104 men and boys on May 13, 1607. Replicas of the three ships constructed for the Jamestown Festival of 1957 were required to appear exactly as depicted in this painting, which now hangs in the Old Senate Chamber of the Virginia State Capitol in Richmond. (Courtesy of the Library of Virginia.)

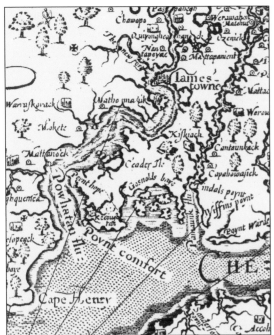

In this detail from John Smith's 1612 *Map of Virginia*, the James River appears as "Powhatan Flu," running diagonally upward on the left (south) side of the image. "James-towne" is shown just above the first great bend in the river, which flows past present-day Hog Island in Surry County. (Courtesy of the Library of Virginia.)

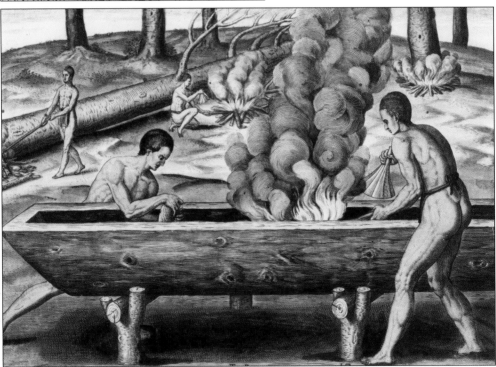

Native Americans are believed to have first appeared in Virginia about 11,000 years ago. The Jamestown settlers of 1607 found the Powhatans thriving on fish, shellfish, game, corn, and other crops. The Powhatans skillfully navigated the James in dugout canoes fashioned from logs, as shown in this engraving by Theodor de Bry from a John White watercolor. (Courtesy of the Library of Virginia.)

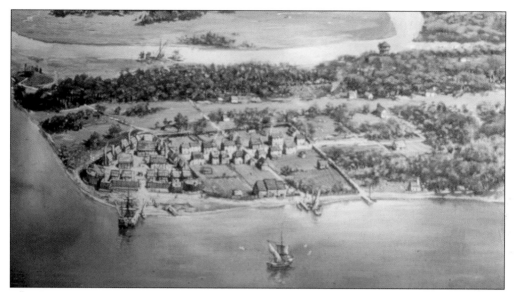

This artist's conception shows the 1607 settlement at Jamestown. The settlement was sponsored by the Virginia Company of London, a stock company. The first few years of the colony were marred by poor leadership, Indian attacks, illness, starvation, and death. On June 7, 1610, Jamestown was briefly abandoned. The beleaguered colonists sailed for England, but three ships with new settlers and provisions met them 10 miles down the river, and they turned back. (Courtesy of the National Park Service.)

Capt. Christopher Newport commanded the 1607 voyage to Jamestown. Shortly after arriving, he and others explored the James River upstream to the falls at present-day Richmond. There, the group met friendly natives who told them about their powerful king, Powhatan, and the mountains to the west. They erected a cross inscribed "Jacobus Rex," claiming the river and land for James I.

In 1611, Sir Thomas Dale and settlers arrived from Jamestown to build a town on a bluff about 40 miles upriver. It was named the Citte of Henricus in honor of Henry, Prince of Wales, and in 1613 and 1619, respectively, the first English hospital and college in the New World were established there. Henricus was destroyed in the Indian Uprising of 1622 and has since been re-created as Henricus Historical Park, a living history museum.

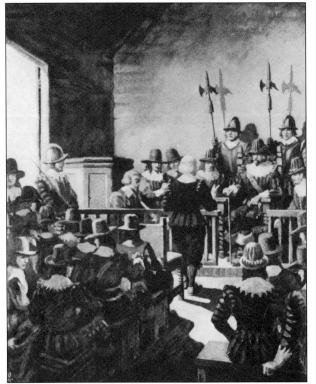

The first representative legislative assembly in English America met in the Jamestown Church on July 30, 1619. Named the House of Burgesses, the assembly was the predecessor of Virginia's modern General Assembly, which is the oldest such body in the United States. Some of its first enacted laws dealt with idleness, drunkenness, and gambling. (From *The English Heritage in America*, Parke Rouse Jr., 1966.)

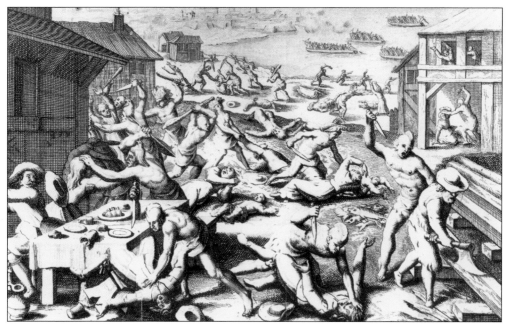

By 1622, there were more than 50 English settlements along the James River. The Indians were displaced from their traditional hunting and farming lands and river frontage. On March 22, 1622 (Good Friday), the Indians attacked settlers along the river, killing about 350 men, women, and children. Jamestown itself was warned of the impending attack by an Indian boy, Chanco, and survived the massacre. (Engraving by Theodor de Bry, *The Indian Uprising of 1622*.)

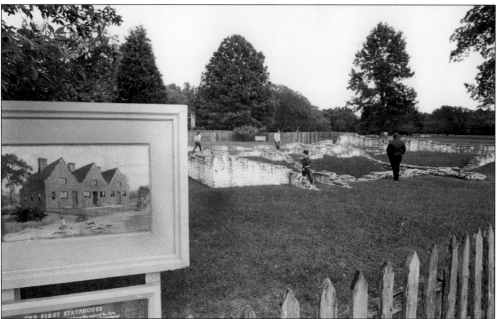

By the end of the 17th century, Virginia was peaceful and prosperous with a population of about 53,000; explorers and settlers had passed through the Allegheny Mountains. The Jamestown statehouse burned in 1698, and the capital was moved five miles inland to Middle Plantation, which was renamed Williamsburg. (Courtesy of the Daily Press, Inc.)

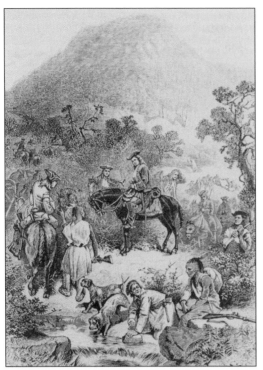

As the Tidewater region of Virginia grew in population and the fertile land was depleted, westward settlement opened territory to the Blue Ridge and beyond. Gov. Alexander Spotswood and his 63 Knights of the Golden Horseshoe explored the valley of Virginia in 1716. The Knights were named after small golden horseshoes, some studded with precious stones, given to each of them after the expedition. (Courtesy of the Library of Virginia.)

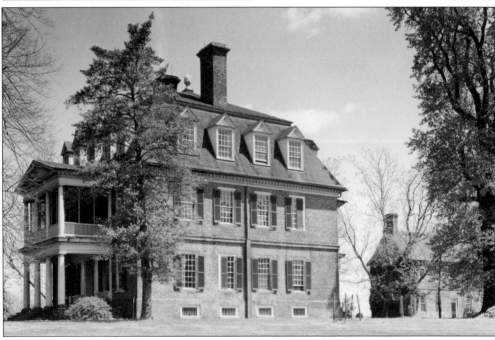

In the east, great plantations and grand homes were built along the James River. Shirley Plantation, in Charles City County, was built by Edward Hill III in 1723. It was modeled after the Governor's Palace in Williamsburg and has been owned by the Carter family since before 1769. Hill's great-granddaughter Anne Hill Carter, the mother of Gen. Robert E. Lee, was born here in 1779. (Courtesy of the Daily Press, Inc.)

Richmond, shown in this 1737 map, began as two villages, established by William Byrd II and James Mayo. Mayo's village was proclaimed a town by the general assembly in 1742, and the two settlements merged to become Richmond a few years later. The state capital was moved here from Williamsburg in 1780. (Facsimile of William Byrd II's map, from *Richmond: Her Past and Present*, by W. Asbury Christian, 1912.)

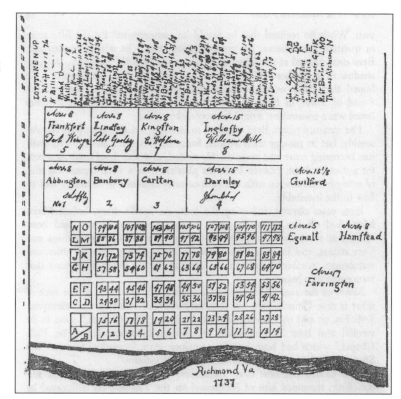

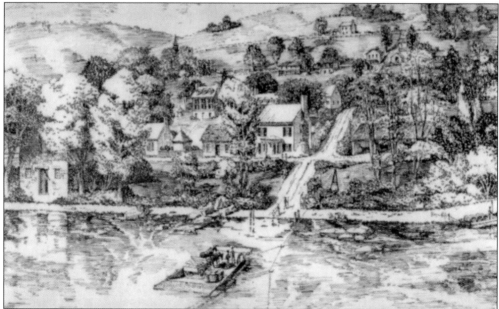

Across the James River, just upstream from a ford that connected the villages of Charlottesville and New London, 17-year-old John Lynch founded a ferry in 1757. The ferry became a trade center, and in 1786 Lynch was granted a charter establishing the town of Lynchburg. The town grew and became a major port for shipping tobacco to Richmond via the river and later on the James River and Kanawha Canal. (Courtesy of the Jones Memorial Library.)

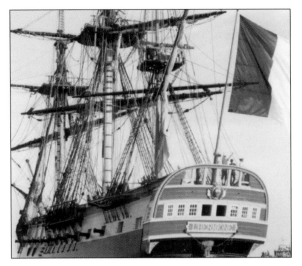

On September 2, 1781, a fleet of transports landed 3,200 French troops on the north bank of the James River below Jamestown. They were the first French troops in Virginia sent to help the Americans fight the British in the Revolutionary War. Under the command of Maj. Gen. Claude-Anne de Rouvroy, Marquis de Saint-Simon, they and others began the siege against the British at Yorktown. In June 2015, a beautiful new replica of the frigate *Hermione*, which brought Lafayette to America in 1780, visited Yorktown to celebrate the friendship between the two nations. (Courtesy of Association Hermione-La Fayette.)

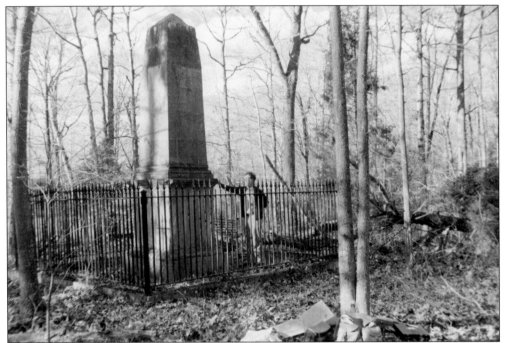

In 1771, the Great Freshet occurred on the James, a flood caused by torrential rains in the Blue Ridge. A 40-foot wave of water swept down the river and killed about 150 people. In 1772, this monument was erected at Turkey Island in memory of Richard and Jane Randolph. On its base is inscribed, "The Foundation of this Pillar was laid in the calamitous year 1771 When all the great Rivers of this Country were swept by inundations Never before experienced: Which changed the face of Nature And left traces of their Violence that will remain for ages." Confederate Maj. Gen. George E. Pickett lived here after the Civil War. (Courtesy of VCNS.)

Two

BUILDING VIRGINIA

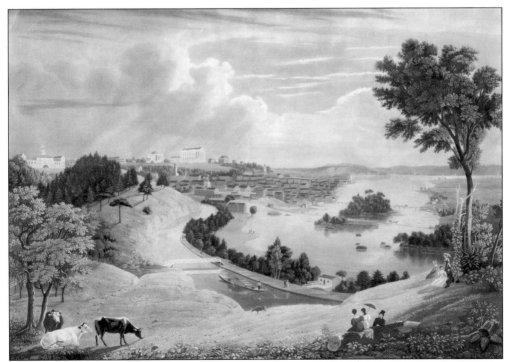

This fine view of Richmond and the James River and canal was painted by George Cooke in 1834. Thomas Jefferson's 1792 capitol is seen to the left of center in this image. (Courtesy of the Library of Virginia.)

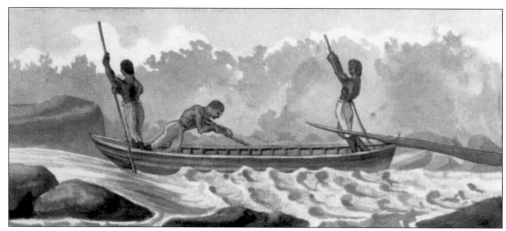

The James River was Virginia's highway until the end of the 19th century. First, dugout canoes, then, larger double canoes, carried cargo, poled up and down the river mostly by free or enslaved black men. While their work was backbreaking, the boatmen were said to have enjoyed a degree of freedom there. (From *An Essay on Landscape*, Benjamin Henry Latrobe, 1798.)

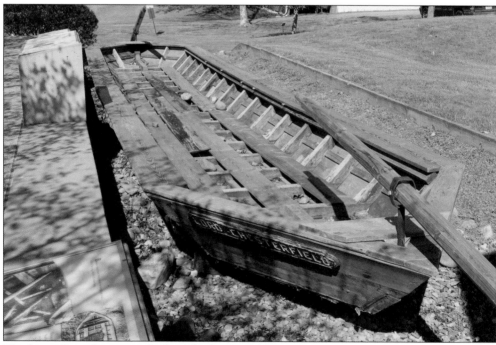

The James River batteau, a shallow, flat-bottomed boat of simple construction, was invented by Anthony and Benjamin Rucker in the 1770s. Batteaux were developed to carry up to 10 hogsheads (barrels) of tobacco weighing 1,000 pounds each. They were poled and steered by long sweeps. Hundreds operated on the river between Lynchburg and Richmond. A replica batteau, the *Lord Chesterfield*, is shown at Scottsville's Canal Basin Square.

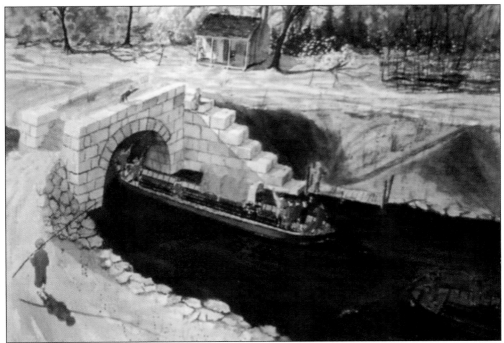

Following his sixth exploratory visit to the then frontier in 1784, George Washington wrote a letter to Virginia governor Benjamin Harrison advocating improvements to the James and Kanawha Rivers to form a highway linking East and West. In 1785, the Virginia General Assembly chartered the James River Company to construct a canal around the falls at Richmond and improve the westward James River. Washington took a batteau tour of the almost-completed canal in 1791, as shown here. (Watercolor by Art Markel, courtesy of VCNS.)

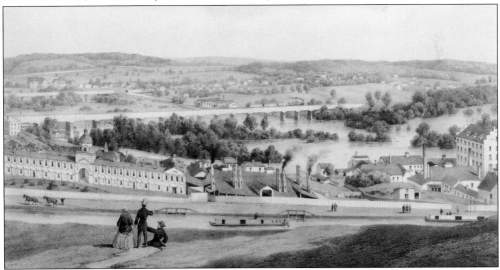

This beautiful 1857 lithograph by Edward Beyer, *View of Richmond from Gamble's Hill*, graces the cover of Parke Rouse Jr.'s 1990 book *The James*. Beyer was a German pastoral and landscape artist who toured Virginia in the 1850s and recorded its beauty in his *Album of Virginia* in 1858. The James River Canal and its towpath are shown in the foreground. (From *Richmond: Her Past and Present*, W. Asbury Christian, 1912.)

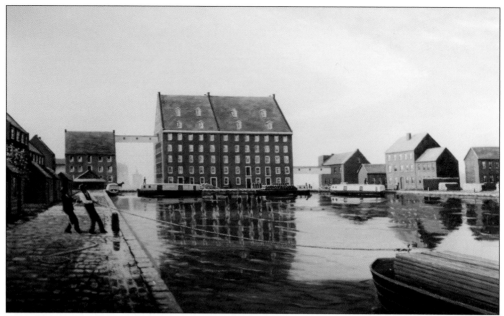

In the heart of Richmond, the Great Basin (Turning Basin) opened in 1800 to dock and load or unload canal vessels. It was the eastern terminus of the canal until the Tidewater Connection with the lower James River was completed in 1854. This beautiful view, *Dawn on the Great Basin*, was painted by Richmond artist Joseph Burrough. The huge Gallego Mills in the background was powered by water from the Great Basin. (Courtesy of Joseph Burrough.)

The Tidewater Connection consisted of five stairstep locks, a connecting canal, and the Great Ship Lock at the tidal James. It finally enabled vessels to travel through Richmond from upriver to locations on the lower river and beyond. This old view looking east at Lock Upper 2 is from the Historic American Engineering Record (HAER) collection of the Library of Congress. (Courtesy of the Library of Congress.)

Construction of the canal west of Richmond proceeded slowly, and the state took control of the James River Company in 1820. In 1832, a charter was granted to the James River and Kanawha Company, a joint-stock company to build a canal and/or a railroad to the Kanawha River. The First Grand Division, from Richmond to Lynchburg, was completed in 1839. This HAER photograph shows the remains of First Grand Division Lock 2, just west of Byrd Park in Richmond. (Courtesy of the Library of Congress.)

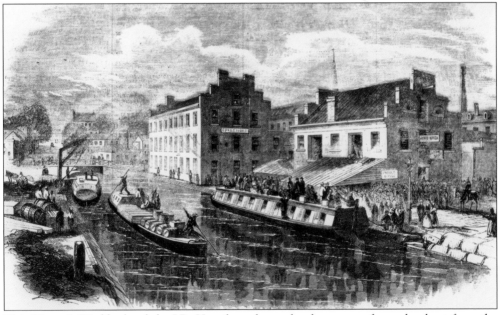

This *Harper's Weekly* sketch by J.R. Hamilton shows the departure of a packet boat from the canal landing at Eighth Street in Richmond in the 1850s. The term *packet* indicated that the boat ran on a regular schedule. Both freight and passengers were carried, and the 150-mile trip to Lynchburg took over 30 hours. The main cabin, or saloon, was used for living, dining, and sleeping during the trip. (Courtesy of the Library of Congress.)

Building the James River and Kanawha Canal required a huge engineering and construction effort, akin to building today's interstate highway system. The canal itself had to be excavated by hand, the towpath was built from the spoil, and numerous locks, bridges, aqueducts, and culverts were constructed. Much of the handsome stonework survives today, but the Rivanna River aqueduct at Columbia, shown here, was razed in the 1940s. (Courtesy of VCNS.)

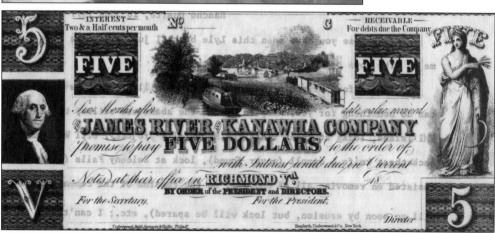

George Washington was the honorary president of the first canal company. The company issued its own notes, paying 2.5¢ per month on this $5 one. A typical canal scene—with a river town, canalboat, and railroad—appears on the note. Although the company was supported by the general assembly, its finances were always an issue. (Courtesy of the Leyburn Library, Washington and Lee University.)

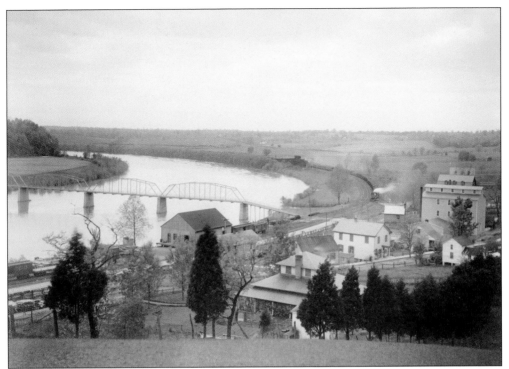

Scottsville, in Albemarle County, lies on a large horseshoe bend in the James River in central Virginia. Edward Scott patented the land here in 1732 and founded Scott's Landing. During the canal era, Scottsville became a large flour market but was heavily damaged by Union troops in 1865 and declined afterward. Today, it survives as a historic and picturesque town with a large number of period houses and churches remaining, like those seen in this 1911 view. (Courtesy of the Library of Congress.)

This peaceful scene on the canal shows Norwood, in Nelson County, at the mouth of the Tye River in the 1850s. The boats are fanciful. The small town and most of Nelson County were devastated, not by the river, but by flash flooding from the remnants of Hurricane Camille in August 1969. More than five inches of rain fell in a half hour, and the record total was 27 inches in three to five hours. (Courtesy of the Leyburn Library, Washington and Lee University.)

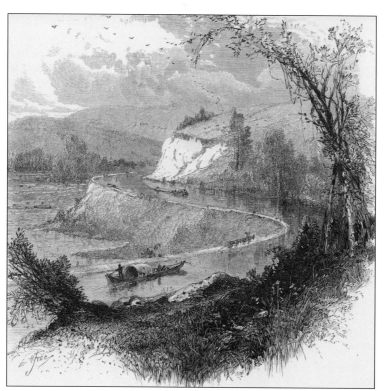

The early Blue Ridge Canal at Balcony Falls, near Glasgow, was completed in 1828. In 1841, it was reconstructed and enlarged and became part of the James River and Kanawha Canal. The canal had to be closed during its reconstruction, resulting in considerable loss of revenue and the loss of boats and lives in the turbulent falls. (Courtesy of VCNS.)

This obviously modern (1972) photograph shows the lock at the Varney's Falls Dam, five miles downstream from Eagle Rock and about 20 miles below Iron Gate. The size and craftsmanship of the lock stonework on the canal is evident. Stones were hand-drilled, cut, and taken from local quarries. Skilled masons were brought from Europe to augment the local labor force. (Courtesy of VCNS.)

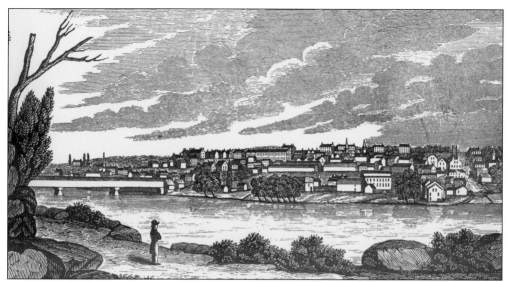

By 1840, Lynchburg's lower canal basin was completed and opened. Lynchburg was a thriving town, and this completed the First Division. Freight traffic greatly increased, and hundreds of boats were employed. (Courtesy of Jones Memorial Library.)

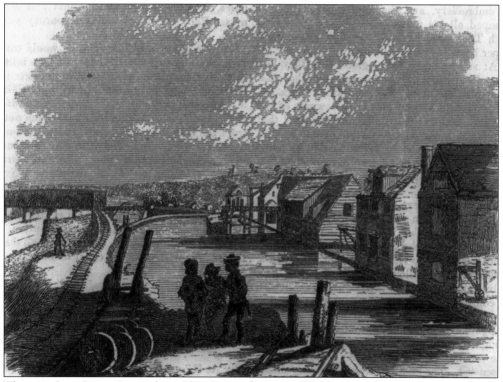

This woodcut, from a September 1857 edition of *Harper's Weekly*, shows Lynchburg's canal basin and the riverfront Virginia & Tennessee Railroad. The packet boat *General Harrison* arrived from Richmond on December 3, 1840, opening the basin. Afterward, many packet and freight boats provided scheduled passenger and freight service between the two cities. (Courtesy of the Library of Congress.)

The 1839 builder's stone still exists on the Ninth Street arch bridge across the canal in Lynchburg. The bridge is still in use. In May 2007, it was the site of a reenactment of Stonewall Jackson's May 1863 funeral procession. (Courtesy of VCNS.)

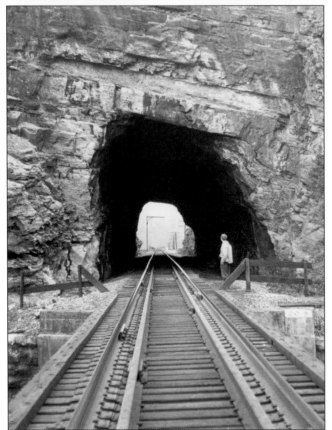

The 189-foot-long Mason Canal Tunnel is located on the large Horseshoe Bend, 10 miles downriver from Eagle Rock. It saved three miles of canal construction but was never used. It was later enlarged and is now CSX's Little Tunnel. (Courtesy of VCNS.)

When Union troops entered Richmond on April 3, 1865, they discovered that fires set by the Confederates to destroy supplies had burned out of control. As a result, much of the city's commercial area along the river was in ruins. This view, looking west along the canal, shows the Eleventh Street Bridge and the ruins of the huge Gallego Flour Mills. (Courtesy of the Library of Congress.)

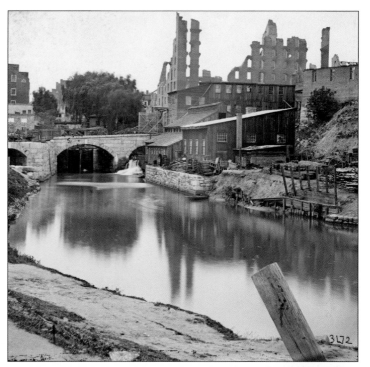

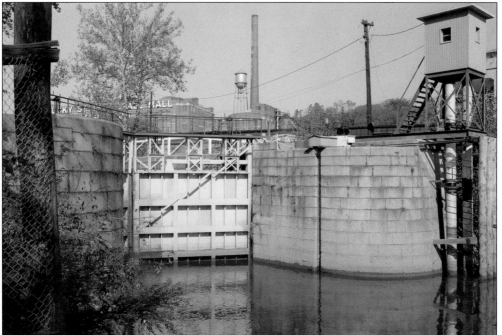

Downriver from the Eleventh Street Bridge, the Great Ship Lock at the east end of the Tidewater Connection was completed in 1854. For the first time, vessels could pass to and from the canal to the tidal James River. The lock could accommodate ships and steamboats up to 180 feet long and 35 feet wide. It was restored and transformed into a park in the 1980s. (Courtesy of the Library of Congress.)

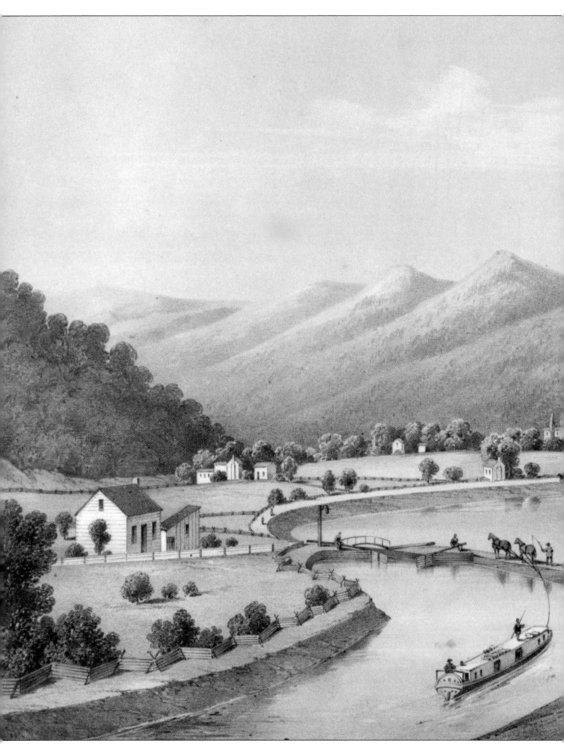

This peaceful view of the river and the canal is from an 1858 color lithograph by German artist Edward Beyer in his *Album of Virginia*. It was originally titled *James River Canal Near the Mouth of the North River*. That river, a tributary of the James at Glasgow in Rockbridge County, was

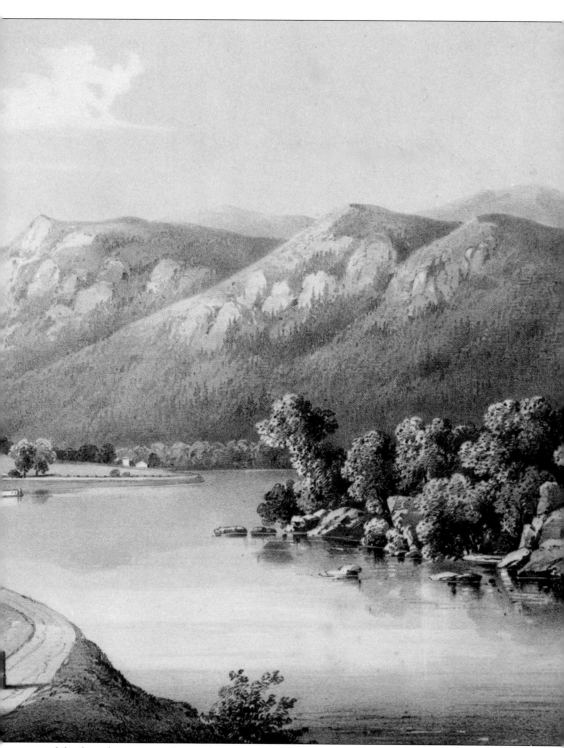

renamed for famed oceanographer and cartographer Matthew Fontaine Maury, the "Pathfinder of the Seas," after his death in 1873. (Courtesy of the Library of Congress.)

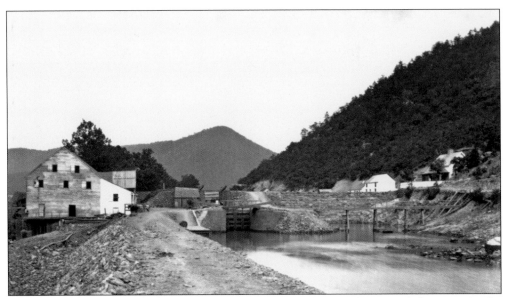

The Locher Cement Mill was built at Blue Ridge Dam in the 1840s. It provided cement for the canal and later for the railroad. The dam and its guard lock were just above Balcony Falls, in the Blue Ridge Gorge (Water Gap) below Glasgow. The mill was later removed. (Courtesy of the Leyburn Library, Washington and Lee University.)

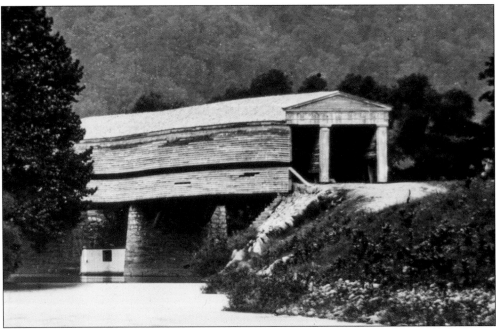

Interestingly, the North (Maury) River Towpath Bridge was slotted to allow the towrope to pass from the towpath through to the canalboat below. The Blue Ridge Turnpike also crossed the bridge. (Courtesy of the Jones Memorial Library.)

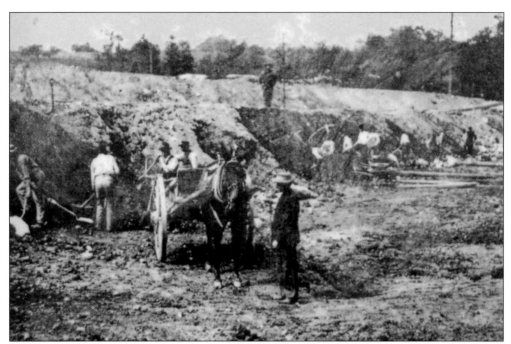

According to *The Canal on the James* by T. Gibson Hobbs Jr., building the canal from Richmond required almost 8.5 million cubic yards of excavation and over 210,000 cubic yards of stonework. Labor was provided by contractors, property owners and their slaves, and imported Europeans, especially the Irish. The work was arduous; all was done by manpower with hand tools and horses and mules. (Courtesy of Scottsville Canal Square.)

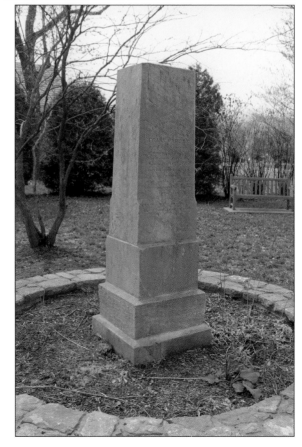

This marker is engraved "in memory of Frank Padget, a coloured slave, who, during a freshet in James' River, in January 1854 ventured and lost his life, by drowning, in the noble effort to save some of his fellow Creature's who, were in the midst of flood, from death." The marker was originally located at Lock 16 on the canal but was moved to Centennial Park in Glasgow around 2003.

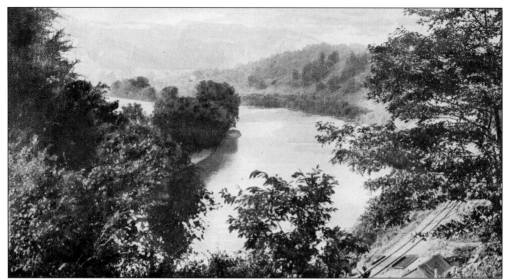

This old postcard shows the James River scenery near Natural Bridge Station after the railroad replaced the canal in the 1880s. Natural Bridge, once owned by Thomas Jefferson, is located about 1.3 miles from the river as the crow flies. It was reached from the station by road. (Courtesy of the Leyburn Library, Washington and Lee University.)

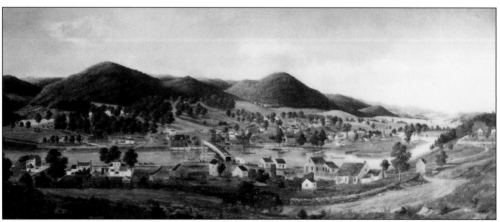

Buchanan, in Botetourt County, became the western terminus of the James River and Kanawha Canal. Beyond it was the Unfinished Division to Eagle Rock. Buchanan was located on the Great Road (now US Route 11), which ran through the Shenandoah Valley from Pennsylvania. This beautiful 1855 watercolor of the town by Edward Beyer shows its busy riverfront during the canal era. The original now hangs in the Bank of Buchanan. (Courtesy of the Buchanan Town Improvement Society.)

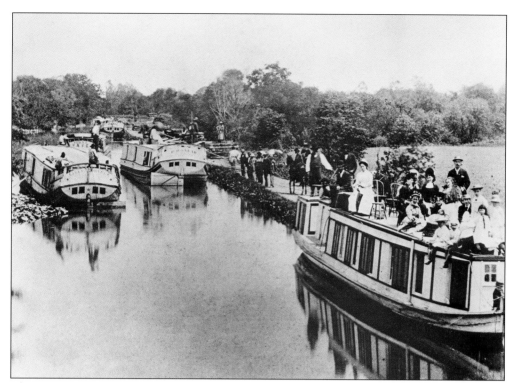

There were never more than a few packet boats on the canal at any one time, but a number of them are shown here near Tuckahoe around 1880. On the right is a small excursion boat. In the background, stacked railroad ties on the towpath predict the coming of the railroad. (Courtesy of COHS.)

The packet boat *Marshall* carried the body of Gen. Stonewall Jackson to Lexington for burial in May 1863. The *Marshall* was known as the "Queen of the River." Measuring 90 by 14 feet, it was built in 1861 with an iron hull and served until being beached at Lynchburg in 1877. (Courtesy of the Leyburn Library, Washington and Lee University.)

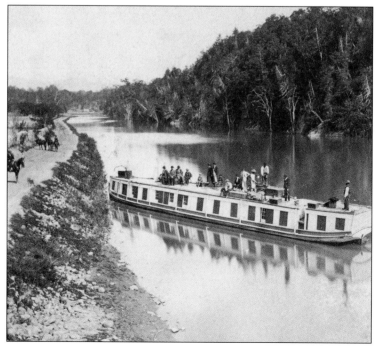

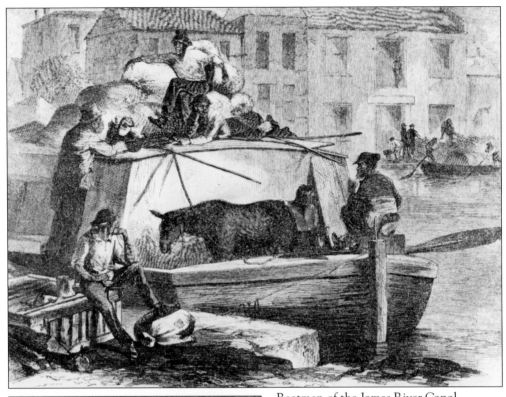

Boatmen of the James River Canal are shown with a freight boat in Richmond's Great Basin in this lithograph from *Richmond: Capital of Virginia*. (Courtesy of VCNS.)

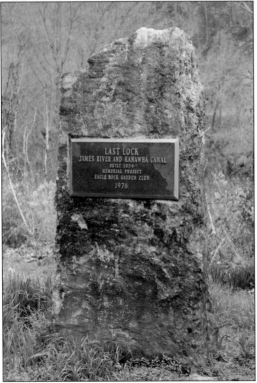

This monument at Eagle Rock marks the location of the westernmost lock on the James River and Kanawha Canal, built in 1854. It is a part of Last Lock Park, created as a memorial project by the Eagle Rock Garden Club in 1976.

This 1867 advertisement in *Boyd's Directory of Richmond City* lists daily freight boats and steamboats from Richmond to as far away as Boston and Memphis. (Courtesy of the Leyburn Library, Washington and Lee University.)

This receipt from Lucado's Daily Line to W.W. Pollard, dated October 5, 1876, is for three sheets of plaster board. Presumably, Lucado, along with managing a line of canalboats, also sold wholesale materials that he could transport on the canal. (Courtesy of the Leyburn Library, Washington and Lee University.)

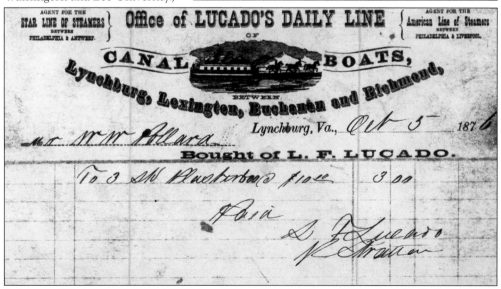

JAMES RIVER & KANAWHA CANAL.

GREAT CHEAP WATER LINE

BETWEEN

Richmond,	Lynchburg,
Lexington,	Buchanan,
Knoxville,	Chattanooga,
Nashville and	Memphis,

CONNECTING WITH

STEAMERS AND VESSELS

TO AND FROM

Norfolk, Baltimore, Philadelphia, New York and Boston.

THROUGH BILLS LADING GIVEN AT FIXED RATES, PER 100 POUNDS. INCLUDING ALL CHARGES.

ALL FREIGHT INSURED ON CANAL.

BOATS LEAVE DAILY.

Mark Goods, VIA CANAL. and Consign to

EDWARD DILLON, Agent.

OFFICES:

| Corner Tenth and Canal, | - | - | - | Lynchburg: |
| Dock Street, between 15th and 17th, | - | Richmond. |

From Boyd's Directory of Richmond City, 1867
Courtesy of Virginia State Library

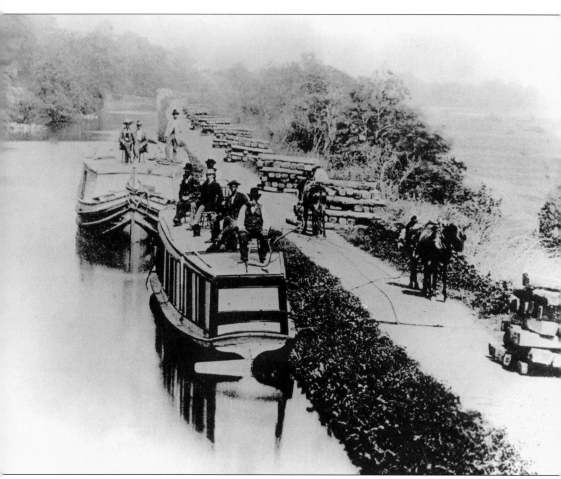

Stacks of railroad ties along the towpath signal the end of the canal in this 1881 view near Tuckahoe Creek, just west of Richmond. In 1880, the Richmond & Alleghany Railroad was chartered to take control of the canal and to lay track on its towpath from Richmond to Clifton Forge. The canal era had clearly passed. (Courtesy of COHS.)

Three

CIVIL WAR

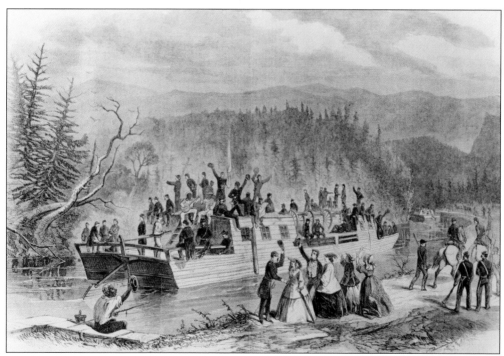

The James River and the canal played an important part in the Civil War. This engraving depicts Confederate troops at Balcony Falls moving from Lynchburg to Buchanan on their way to western Virginia in 1861. The boat in the drawing is made-up; no such type ever existed on the James River. (From *Harper's Weekly.*)

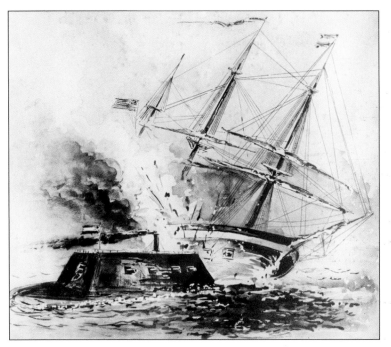

The Confederates converted the burned hulk of the steam frigate USS *Merrimack* into the innovative ironclad ram CSS *Virginia* at Portsmouth in 1862. On March 8, 1862, it attacked and easily destroyed the wooden Union warships USS *Cumberland* and USS *Congress* off Newport News, at the mouth of the James River. (Courtesy of the Library of Congress.)

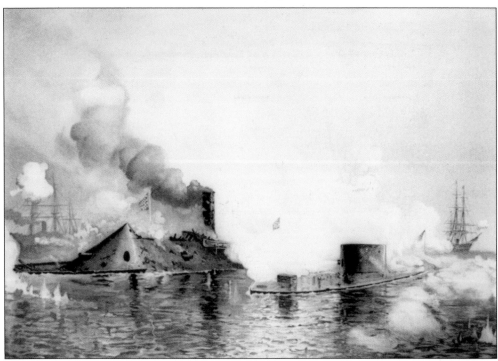

On the next day, the CSS *Virginia* returned to battle. But the newly arrived Union ironclad USS *Monitor* engaged it in Hampton Roads, off Newport News Point. The battle was inconclusive, but it was the first ever fought by ironclads, revolutionizing naval warfare. As its draft was too great to escape up the James River, CSS *Virginia* was scuttled and destroyed by the crew on May 11, 1862. (Courtesy of the Library of Congress.)

The Tredegar Iron Works, located between the canal and the James River in Richmond, was founded in 1837. It was named for Tredegar, Wales, hometown of the ironworkers who helped build it. By 1860, it was one of the largest ironworks in the United States. During the Civil War, Tredegar manufactured much of the iron and artillery for the Confederate States of America, including the armor for the ironclad CSS *Virginia*. (Courtesy of the Library of Congress.)

In the early 18th century, the Rockett family ran a ferry across the James, just below the falls and Richmond. On April 4, 1865, President Lincoln landed at Rocketts, aboard the steamer *River Queen*. (Courtesy of the Library of Congress.)

The Confederate naval shipyard was located on both sides of the James River at Rocketts. With industries, coal mines, and iron close by, it was one of the most productive shipbuilding centers in the Confederacy. (Courtesy of the Library of Congress.)

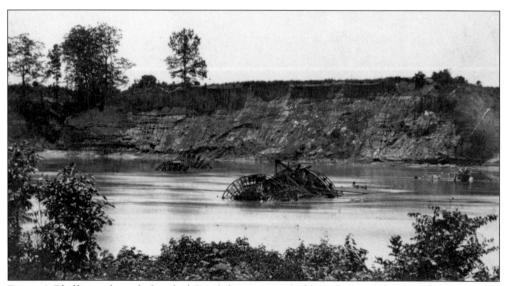

Drewry's Bluff was a heavily fortified Confederate stronghold on the south bank of the river, seven miles downriver from Richmond. It was a 90-foot bluff with strong fortifications for defense against attacks from land or river and was called "a perfect Gibraltar." It was the de facto headquarters of the Confederate Navy. (Courtesy of the Library of Congress.)

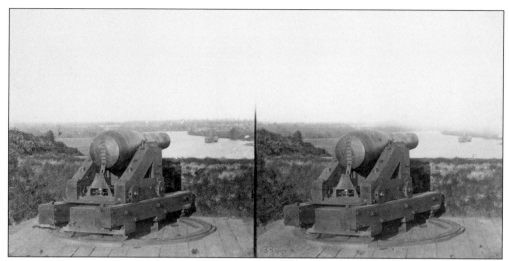

The caption for this 1865 stereograph is "One Reason why we did not go to Richmond." Many guns, including one 10-inch and two eight-inch Columbiads like the one shown, had commanding positions and effectively prevented Union ships from steaming upriver and attacking Richmond. (Courtesy of the Library of Congress.)

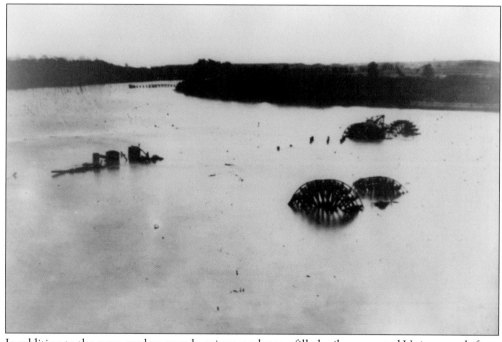

In addition to the guns, sunken vessels, mines, and stone-filled cribs prevented Union vessels from steaming up the river. At the Battle of Drewry's Bluff on May 15, 1862, troops, marines, and the crew from the CSS *Virginia* also rained fire upon the Federal fleet that appeared at 6:30 a.m. The lightly armored USS *Galena* was heavily damaged and retreated. The USS *Monitor* was unable to elevate its guns enough to return fire. The battle was a great victory for the Confederates. (Courtesy of the Library of Congress.)

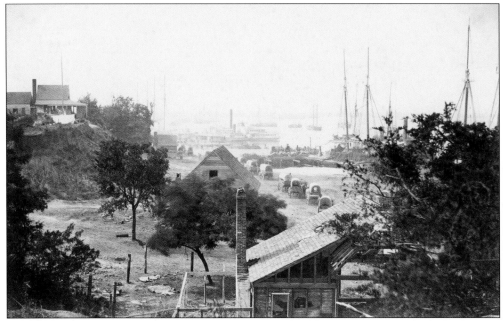

City Point, now in Hopewell, was originally in Charles City County and was called Charles City Point. Sometime after Prince George County was established in 1702, the area became part of it. This view of City Point in 1865 shows how the river was filled with power and sailing vessels that brought troops, equipment, and supplies to Grant's Federal army. Cargo was put ashore here and transported to the front by railroad. (Courtesy of the Library of Congress.)

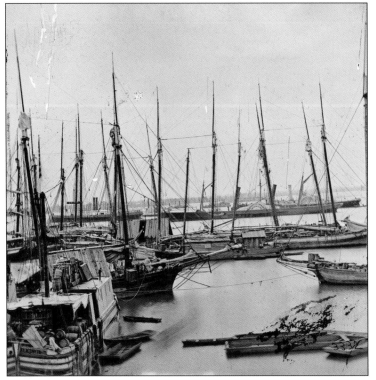

This is another 1865 view of the harbor at busy City Point. A large Federal hospital and railroad complex were also located here. Today, the point is a large park, with museums and restored buildings. (Courtesy of the Library of Congress.)

During the summer of 1864, pontoon bridges were built across the James River to move Union troops and equipment toward Petersburg. The one shown here was located at Deep Bottom at Varina in Henrico County, below Richmond. The longest (2,100 feet; 101 pontoons) pontoon bridge of the war was built downriver at Weyanoke Point, in Charles City County, on June 14–15, 1864. (Courtesy of the Library of Congress.)

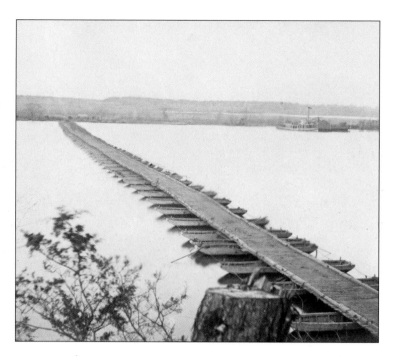

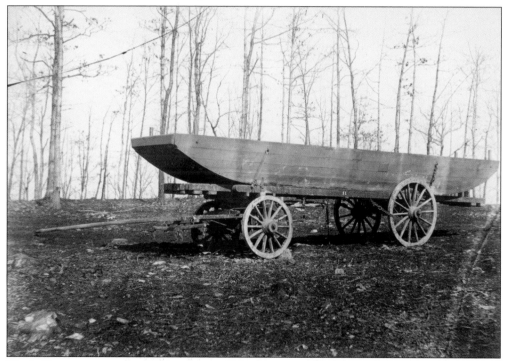

The bridge pontoons were either canvas stretched over wooden frames or wooden pontoon boats. They were carried on wagons, as shown in this 1864 photograph. The heavy wooden boats were about 30 feet long and were used for the longer bridges. The troops had to walk, not march in step, across in order to prevent oscillations that might shake the bridge apart. (Courtesy of the Library of Congress.)

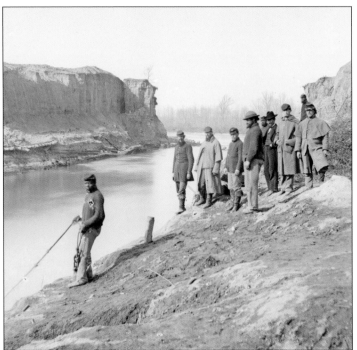

In late 1864, Union general Benjamin Butler ordered a canal to be dug at Dutch Gap to enable Union gunboats to avoid fire from Confederate batteries on the loop in the river. Sir Thomas Dale founded the town of Henricus here in 1611. Drawing on his experience in Holland, Dale had a ditch dug for its defense, but the ditch had filled in during the succeeding generations. (Courtesy of the Library of Congress.)

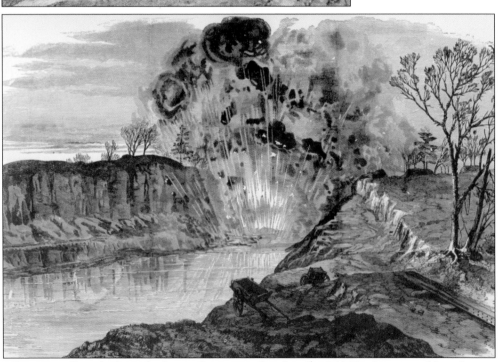

After great effort, the large ditch was almost completed in April 1865, when it was blasted open. The river rushed through and filled it with mud and debris, and work was abandoned. In the 20th century, it was excavated and deepened using modern equipment, becoming a deepwater shipping channel that cut seven miles off the passage up and down the river. (From *Leslie's Illustrated Civil War: The Story of our Civil War*, 1894.)

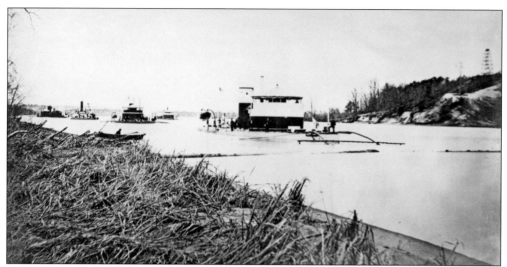

The Battle of Trent's Reach took place on January 23–25, 1865. Trent's Reach was below Farrar's Island and Dutch Gap. To defend the river, the Confederate James River Squadron steamed downstream undetected on the night of January 23. But the men were discovered and fired upon. The armed tender CSS *Drewry* was destroyed and the ironclad CSS *Virginia II* was grounded and damaged. The battle was over and the damaged fleet retreated upriver, no longer a threat. (Courtesy of the Library of Congress.)

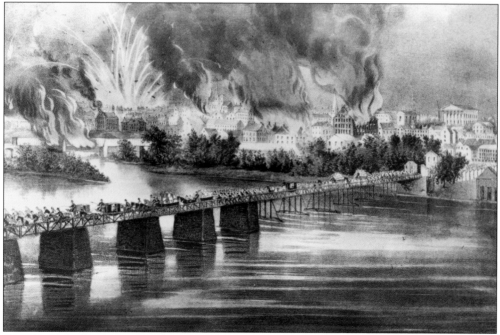

Grant's siege of Richmond and Petersburg in 1864 and 1865 finally led to the fall of Richmond on April 2, 1865. The Confederate government fled to Danville and refugees crowded across the city's bridges, including Mayo's Bridge, shown here. It had been decided beforehand that if the city fell, its valuable tobacco warehouses would be set on fire. This was done and the resulting fire raged out of control and destroyed the waterfront and business district. (Courtesy of VCNS.)

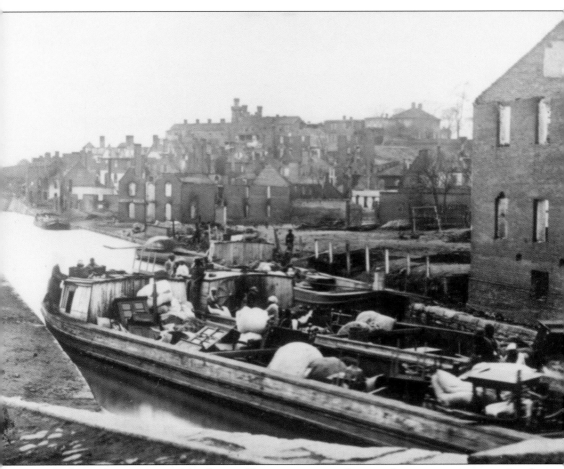

Richmond was a scene of desolation. Hunger was everywhere, and many were in mourning, but there was praise for the conduct of the Union troops. A third of the population was forced to subsist on food from them. On April 4, President Lincoln and his son Tad visited the stricken capital, and citizens were impressed with his benevolent spirit. This view looking westward over the canal is from the Seventh Street Bridge. (Courtesy of VCNS.)

Four

A NEW DOMINION

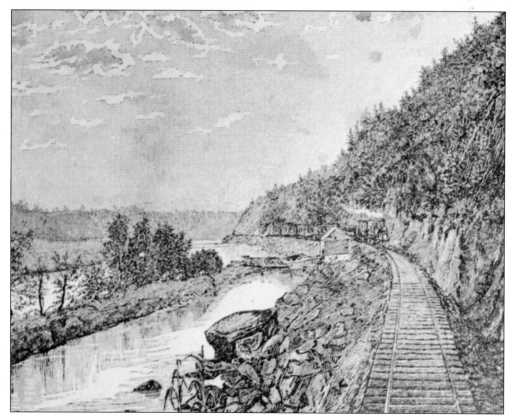

Floods in 1870 and 1877 ruined the canal company and it was taken over by the Richmond & Alleghany Railroad in 1880. Rails were laid down mainly on the towpath, starting at Clifton Forge and Richmond and meeting at Lynchburg. The canal remained open and carried its normal traffic as well as equipment for the new railroad. This 1882 view shows the new railroad and the river and canal at Big Island, west of Lynchburg. (Courtesy of COHS.)

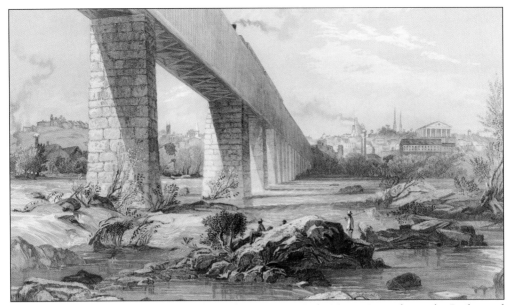

This dramatic 1871 view of Richmond and the James River by Harry Fenn shows the Richmond and Petersburg Railroad Bridge in the foreground. The city was rebuilding. The bridge covering protected the bridge, not the train, which is seen on top. (From *Picturesque America*, D. Appleton & Co., 1872, courtesy of VCNS.)

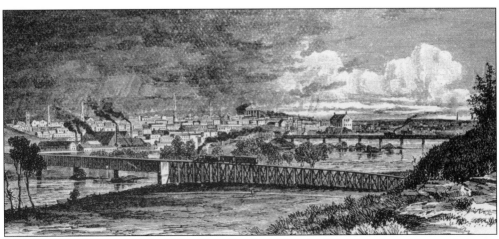

In 1875, Edward King published *The Great South: A Record of Journeys* about his travels in the postwar south. His book was liberally illustrated by J. Wells Chapney. This view of Richmond from the Manchester (south) side of the James shows the mostly rebuilt city with trains running and smoke coming from the Tredegar Iron Works, which survived the war. The state capitol building appears in the center of the image. (From *The Great South*, Edward King, 1875.)

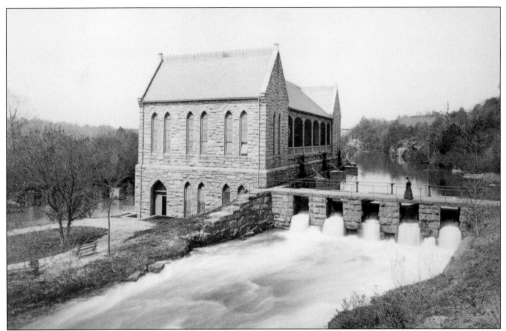

With the canal closed in Richmond, a pump house and supply canal were built to pump river water up to the 1786 Byrd Park Reservoir in 1881–1883. The handsome pump house was built of gray granite in Victorian Gothic style. Pumps were located on the ground floor, while the upper floor was a pavilion used for public events. (From *Art Work of Richmond*, W.W. Scott, 1897.)

The tracks were laid on the old towpath, west of Richmond between the river and the canal. This view is looking upriver, above the falls. The Belt Line Bridge, built to bypass the Richmond and Petersburg Railroad Bridge, is in the background. The elegantly dressed trespasser has nowhere to go if a train approaches. (From *Art Work of Richmond*, W.W. Scott, 1897.)

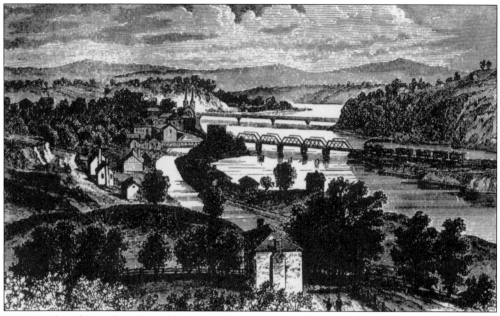

In 1875, Edward King found Lynchburg "standing among the fertile lands and boasting considerable activity, with 35 tobacco factories." He noted that, in 1871, a total weight of 17,425,439 pounds of tobacco was inspected there. This view on the James River is from below the city, with the South Side Railroad bridge in the center. Island Yard is visible to the right of the bridge. (From *The Great South*, Edward King, 1875.)

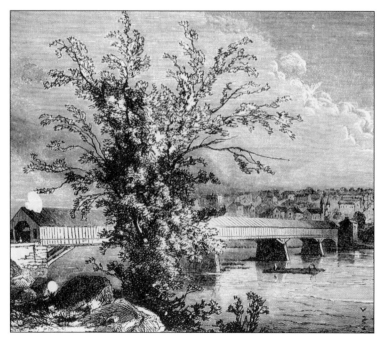

In this view of Lynchburg, the river shows one of its "seven hills" in the background and the covered Ninth Street toll bridge to Amherst in the foreground. This bridge was destroyed by a flood in 1877. The canal ran along the river just behind the waterfront buildings. (From *The Great South*, Edward King, 1875.)

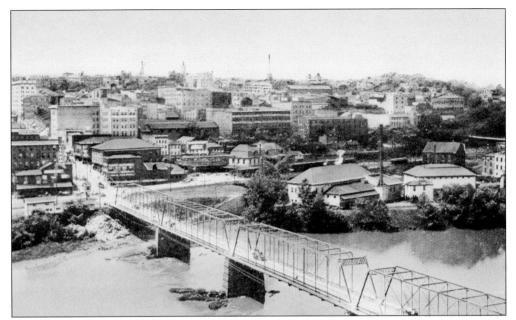

This postcard view of Lynchburg shows the iron bridge at Ninth Street that replaced the wooden toll bridge. This is where John Lynch founded his ferry in 1756. Union Depot appears in the center of the image. The old Virginia & Tennessee Railroad roundhouse previously stood in the open area adjacent to the bridge. This card was mailed in 1917. (Courtesy of Kurt R. Reisweber.)

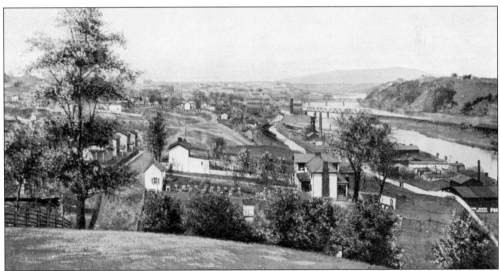

Another postcard shows Lynchburg from White Rock Hill, in a view looking upriver. The Blue Ridge and Peaks of Otter are visible in the background. Industry dominates the riverbank, but terraced yards and handsome homes line the hill. This view is similar to the earlier one shown on the previous page. (Courtesy of Kurt R. Reisweber.)

This view of Newport News Point appears in the May 1859 issue of *Harper's New Monthly Magazine*. It is the earliest known depiction of the future location of the city. Just two years later, Camp Butler would be established by the Union army here. In March 1862, the famous Battle of the Ironclads between the USS *Monitor* and the CSS *Virginia* took place in these waters. (Courtesy of the Mariners' Museum.)

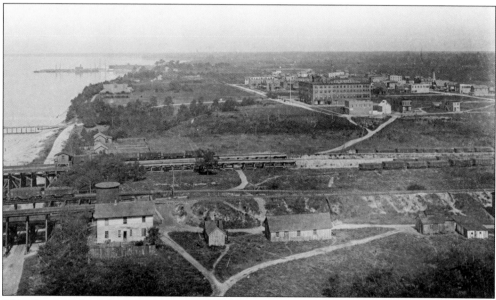

This photograph of the growing town of Newport News was taken in September 1889. The first train had arrived on the new line from Richmond in October 1881, and scheduled service began on May 1, 1882. The luxurious Hotel Warwick, opened in 1883, is to the right of center in the photograph. The young Newport News Shipbuilding and Dry Dock Company, founded as the Chesapeake Dry Dock and Construction Company in 1886, is in the left background. (Courtesy of the Virginiana Collection, Main Street Library, Newport News Public Library System.)

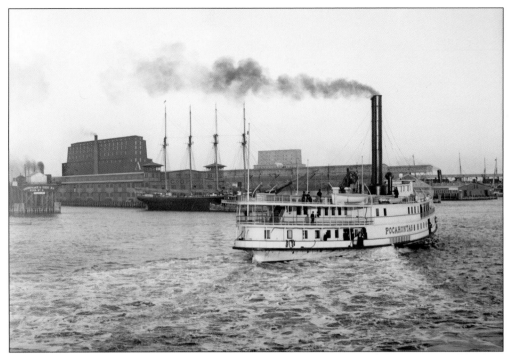

The C&O piers at Newport News are seen in the backdrop of this old Detroit Publishing Company postcard from around 1909. Two large grain elevators dominate the skyline. A large schooner is at the pier, and the *Pocahontas* is in the foreground. (Courtesy of the Library of Congress.)

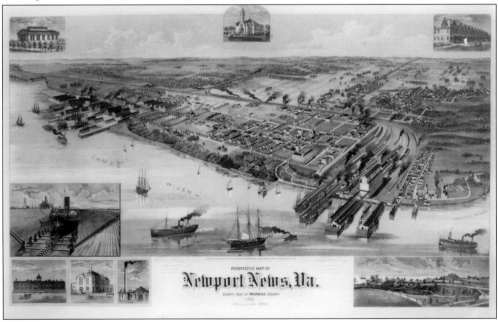

This lithographic bird's-eye view of Newport News in 1891 shows the growing town, the railroad, and the shipyard. The town's population was given as 8,000; it had been just 30 in 1880. The monitor USS *Puritan* in the shipyard's first dry dock and the shipyard's main office building are shown on the left. Casino Park is at the lower right. (Courtesy of the Library of Congress.)

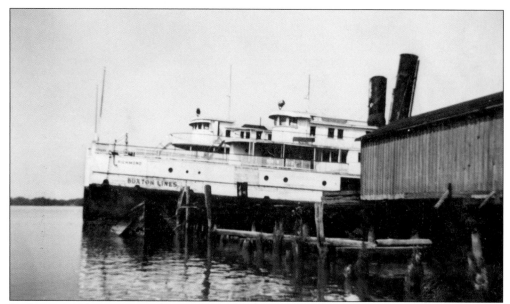

In this image, the steamer *Richmond* and another vessel are moored at Clermont. Steam-powered vessels were tried on the canal in the 1840s, but they damaged the canal banks and their use was discontinued. Steam power on the lower river, below Richmond, was another matter. Beginning in 1815, there were steamboats on the James until the 1920s. Scheduled passenger and freight service between Richmond and Norfolk linked the small communities along the river for over 100 years until the advent of the automobile. (Courtesy of the Surry County Historical Society.)

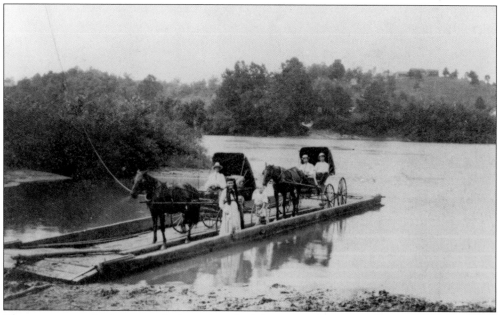

There were many ferries across the James in colonial times, and two are still active today. Depicted here, the Hatton Ferry, 5.5 miles upstream from Scottsville, was founded in the late 1870s. It was threatened in 2009 but is now operated seasonally on weekends by a nonprofit organization. One of the last poled cable ferries in the United States, it now carries two cars instead of two buggies. (Courtesy of the Scottsville Museum.)

The paddle steamer *Eagle* was built in Philadelphia in 1813. Only 110 feet long, it steamed from Norfolk to Richmond in 21 hours on June 30, 1815, becoming the first steamboat on the James River. The *Richmond Enquirer* reported, "All who saw the splendid stranger hailed it with enthusiasm." Over the years, about 100 steamboats were operated on the James. (Courtesy of the Mariners' Museum.)

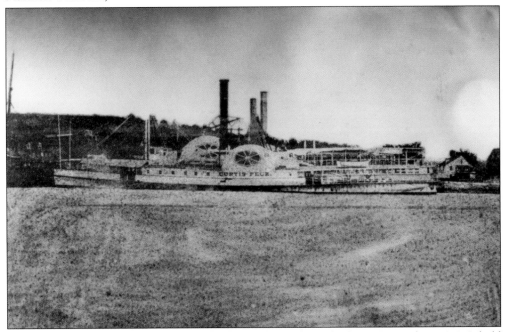

The fast and comfortable wooden side-wheeler *Curtis Peck* was built in New York in 1842. It held the record between Norfolk and Richmond of 7 hours and 15 minutes and ran on the James from the late 1840s until the Civil War. It was sunk at Drewry's Bluff in September 1862 to block the river approach to Richmond. (Courtesy of the Mariners' Museum.)

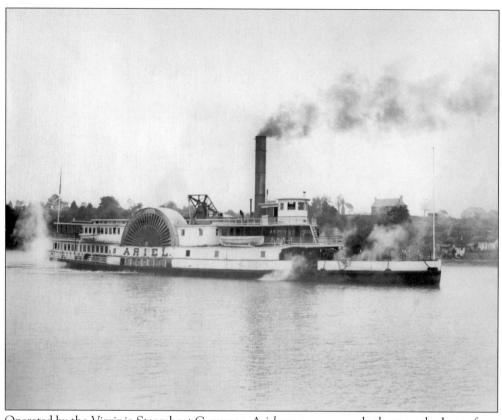

Operated by the Virginia Steamboat Company, *Ariel* was a very popular boat on the James from 1878 to 1893. It was built at Wilmington, Delaware, in 1858. One of the first iron passenger boats in the country, it was 180 by 29 feet and 493 gross tons. Like many other steamboats of that era, it had an extremely tall smokestack, required to provide natural draft for the boilers. The boat was scrapped in 1904. (Courtesy of the Ewen collection.)

Ariel was a day boat, meaning that it stopped at many river landings during the day. Sometimes, stops were requested by displaying a flag on shore; or, less frequently, boats would be rowed out to meet the steamer. Other steamers served on the coastal run from Northern cities and were called night steamers. They ran directly from Norfolk to Richmond overnight. (Courtesy of the Mariners' Museum.)

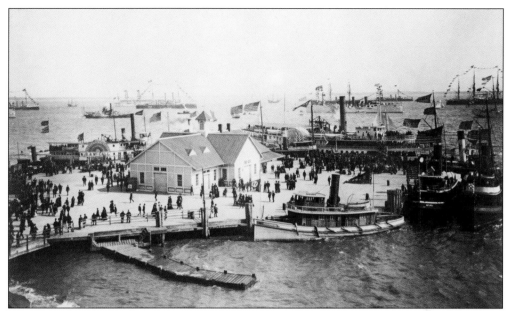

In this 1893 photograph, the *S.A. McCall* is to the left of the Old Point Comfort terminal building during the Columbian Naval Review. It was built as a buoy tender in Boston in 1863 and ran from Petersburg to Norfolk for a number of years. The *S.A. McCall* was 132.5 by 22 feet and 207 gross tons. It was said that it broke down often and the *Ariel* steamed to its aid. (Courtesy of the Mariners' Museum.)

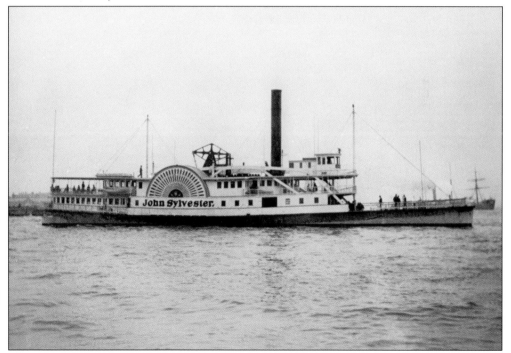

The graceful side-wheeler day boat *John Sylvester* was on the James River from 1866 to 1878. Built at Jersey City, New Jersey, for service between Norfolk and Richmond, the boat measured 207 by 30 feet and 496 gross tons and was capable of 18 knots. (Courtesy of the Ewen collection.)

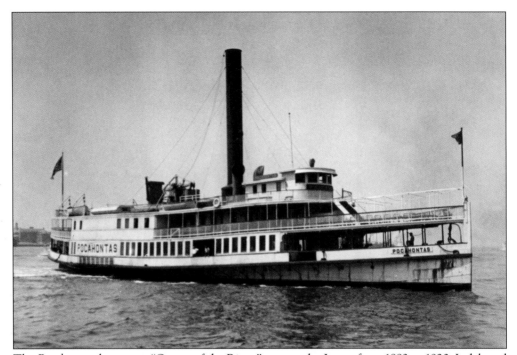

The *Pocahontas*, known as "Queen of the River," was on the James from 1893 to 1920. It debuted with ceremony on July 1, 1893, and ran from Norfolk to Richmond for the next 28 years. It was built in Wilmington, Delaware, for the Virginia Navigation Company. The boat measured 195 by 57 feet and 814 gross tons, and its 750-horsepower steam engine and twin side wheels drove it at a top speed of 20 miles an hour. (Courtesy of the Mariners' Museum.)

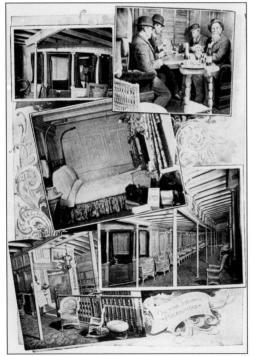

Pocahontas, nicknamed "Poky-hontas" or "Poky," was a palace steamer with a large 34-by-34-foot social hall and a 29-by-11-foot lunchroom. As shown, it was luxurious, with plush carpeting, comfortable furnishings, and an orchestrion (electric orchestra) on its promenade deck. For all of this, its one-way fare was $1.50 plus 50¢ for meals. Modern-day travelers on I-64 can only dream of a trip to Richmond on the *Pocahontas*. (Courtesy of the Mariners' Museum.)

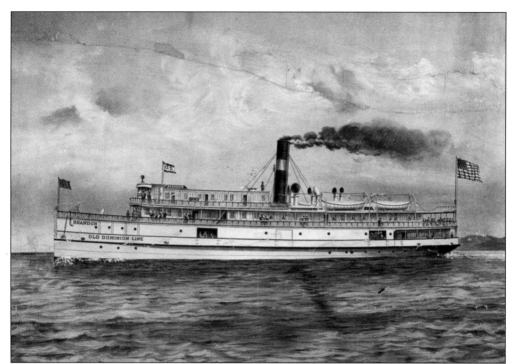

Brandon was one of the last steamboats on the river. The James River steamer would depart Norfolk at 6:00 a.m. It would stop at Old Point, Newport News, Burwell Bay, Hog Island, Kingsmill, Scotland, and Jamestown. From there, it would travel to Claremont, Brandon, Weyanoke, Westover, and Berkeley. Then, it continued to Bermuda Hundred and Shirley before arriving at Richmond at 7:30 p.m. The *Brandon* was sent to Maine after it left Virginia. (Courtesy of the Mariners' Museum.)

Hampton Roads was another later steamboat on the James. It was acquired by the Old Dominion Line in 1896 and put into Smithfield service from Norfolk and Newport News. It carried many passengers, peanuts, and hams on that route until about 1933. (From *Art Work of Richmond*, W.W. Scott, 1897.)

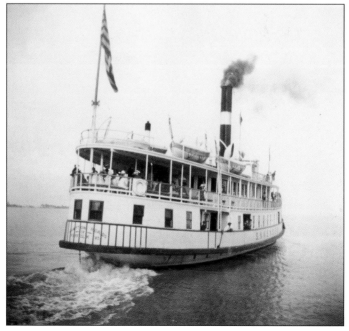

This rendering shows a Virginia Central Railroad train meeting stagecoaches on the James River and Kanawha Turnpike Midland Trail, west of Clifton Forge, in the late 1850s. The Virginia Central was formed in 1850 from the Louisa Railroad, founded in 1836. (Courtesy of COHS.)

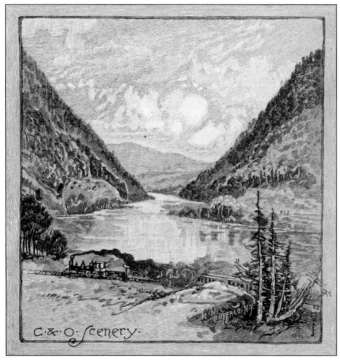

The Virginia Central was important to the Confederacy during the Civil War. In 1868, it, the Blue Ridge Railroad, and the Covington & Ohio merged to form the Chesapeake & Ohio (C&O). Collis P. Huntington took control in 1869. Thus, the "Great Connection" between the East and the Ohio River was completed. This woodcut shows a C&O train headed eastbound out of Clifton Forge, along the headwaters of the James River near Rainbow Rock. (From *The Virginias*, vol. 5, no. 5, May 1884, courtesy of COHS.)

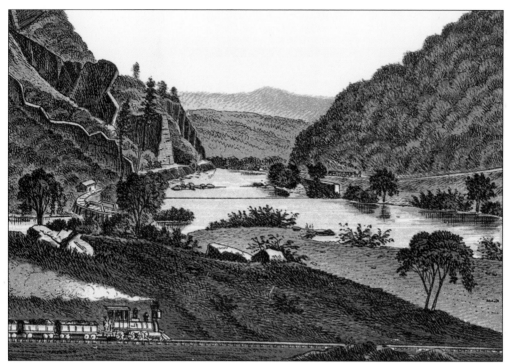

This 1870 woodcut from a C&O publication shows trains at Rainbow Gap, below present-day Clifton Forge and just above the head of the James. (Courtesy of COHS.)

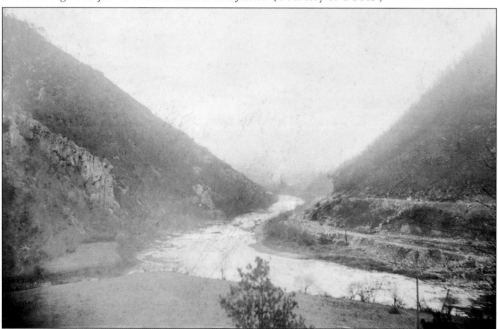

Trains move through Iron Gate Gorge, south of Clifton Forge, before the Jackson River Bridge was built around 1890. On the left is the C&O line over the Mountain Subdivision. On the right is the Richmond & Alleghany Railroad, following the James River. The C&O leased the Richmond & Alleghany in 1888 and acquired stock control in 1889. (Courtesy of COHS.)

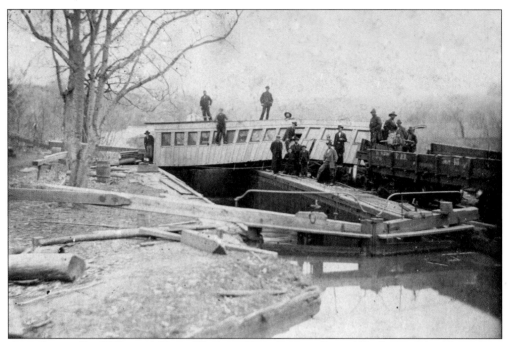

According to Dr. William E. Trout III's *James River Batteau Festival Trail*, "Just after the railway tracks were laid on the towpath in 1880–1881, a train had a grand wreck at Lock 22 (two miles downriver from Scottsville) when it ran into the balance beam of the lock gate." (Courtesy of the Scottsville Museum.)

This undated Foster Studio photograph appears to be of an excursion boat from the later days on the canal near Richmond. The boats were fitted with an exterior stairway located in a notch in the house side, seen on the left. Modern safety items, such as handrails and lifesaving equipment, are nowhere to be seen. (Courtesy of COHS.)

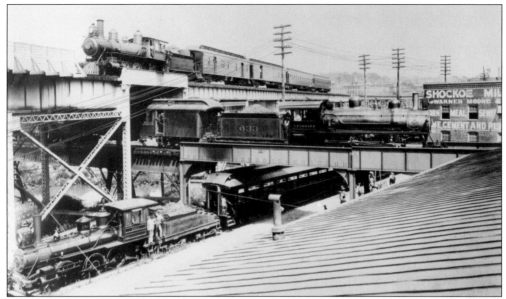

This is the famous "Triple Crossing" on the Richmond waterfront in 1905. It is thought to be the only place in the United States where three Class I railroads cross in the same place. A C&O 4-6-0 is on the James River Viaduct with a westbound passenger train. On the middle track is a Seaboard 4-6-0 with a passenger train headed south. On the bottom is a Southern 0-6-0 switcher pulling a passenger car. The Triple Crossing still exists; it is now used by CSX Transportation and Norfolk Southern. (Photograph by Dementi Studios, courtesy of COHS.)

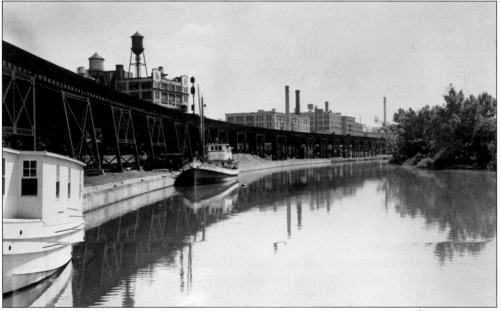

The James River Viaduct was built along the river through Richmond by the C&O in 1901. It connected the James River Line to the C&O's Piedmont line from Charlottesville and west and the Peninsula line to Newport News. Today's Amtrak riders enjoy a close-up view of the Richmond waterfront and canal from it. In this 1920 view, the city's famous Tobacco Row factories, now apartments and condominiums, appear. The Great Ship Lock is at right. (Courtesy of COHS.)

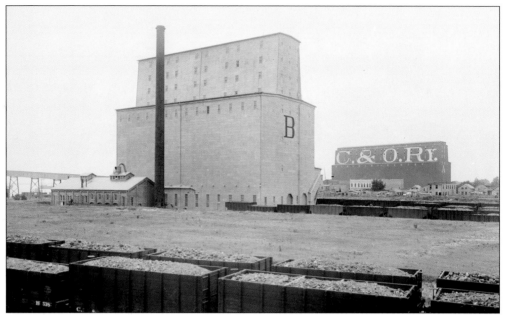

The new city of Newport News grew, and the C&O's facilities grew with it. This Detroit Publishing Company view shows the huge grain elevators in 1905. Built of wood and sheet metal, they were designated A and B. Elevator A had a capacity of 1.5 million bushels. Both later burned—in 1915 and 1934, respectively. They were favored vantage points before the advent of airplanes and aerial photography. (Courtesy of the Library of Congress.)

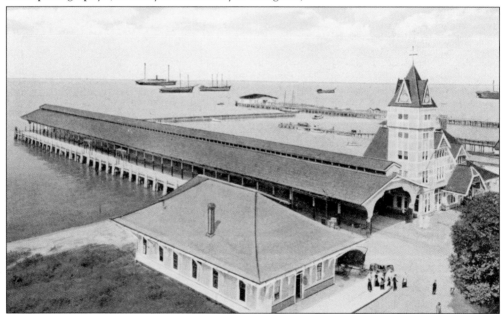

Built in 1892, the ornate yellow-and-white Carpenter Gothic depot at Newport News was flanked by a long pier with a shed roof. Passenger trains would run out onto the pier, and passengers could conveniently transfer to steamers to Norfolk. The old depot was razed and replaced with a modern brick Colonial station in 1940. The pier was retained, but steamer service ended in 1950. In 1981, a new station was built uptown and the brick station became a restaurant. (Courtesy of VCNS.)

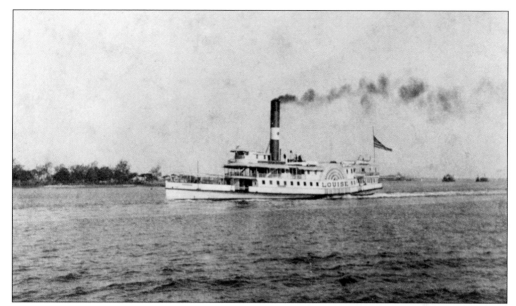

In 1881, *Ariel* became the first C&O transfer steamer between Newport News and Norfolk. It was succeeded by the *Northampton* and the *Luray* in 1883. All were operated by or leased from other companies. In 1886, the C&O purchased the *John Romer*, built in New York in 1863. In 1889, the boat was renamed *Louise* after the daughter of the railroad's president. The graceful old *Louise* remained in service until it was replaced by the new *Virginia* in 1902. (Courtesy of the Mariners' Museum.)

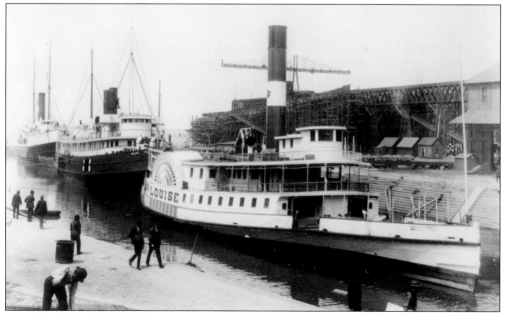

The *Louise* and steamships *Olivette* and *Miami* were docked in Dry Dock 2 when it opened at the Newport News Shipbuilding and Dry Dock Company in May 1902. The shipyard, founded in 1886 to repair ships calling at the Port of Newport News, grew to become a major shipbuilder. By 1898, it was building large cargo vessels and battleships for the Navy. (Courtesy of Huntington Ingalls Industries, Inc.)

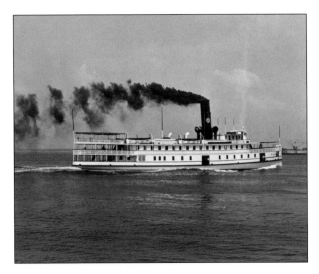

The *Louise* was replaced by the new *Virginia*, built for the C&O by the William R. Trigg Company of Richmond in 1901. Trigg reportedly built it in exchange for C&O land near the Great Ship Lock on which to expand his shipyard. The *Virginia* was a fast twin-screw vessel, and the people of Newport News came to look upon it with great affection. Its familiar plume of black smoke earned the boat the nickname "Smoky Joe," and everyone in town knew the sound of its whistle. (Photograph by John Lochhead, courtesy of the Mariners' Museum.)

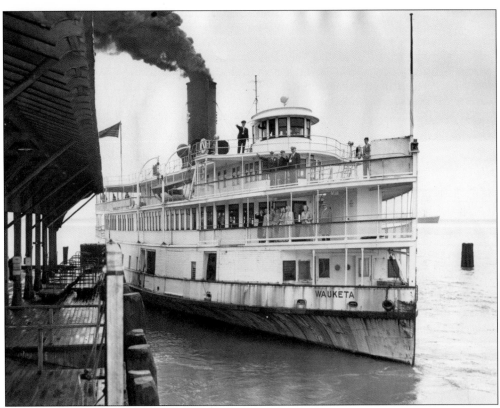

In 1944, the C&O bought passenger steamer *Wauketa*, which had been built in Toledo, Ohio, in 1909. It served as a relief and extra boat alongside the *Virginia*. Both steamers ferried thousands of soldiers and sailors across Hampton Roads during World War II. *Wauketa's* final departure from Newport News, on June 8, 1950, is shown here. The beloved *Virginia* was retired in 1949. The boats were replaced with bus service. It was the end of steamboating on the James River. (Courtesy of the Daily Press, Inc.)

Five

DOWN THE JAMES, FROM IRON GATE TO NEWPORT NEWS

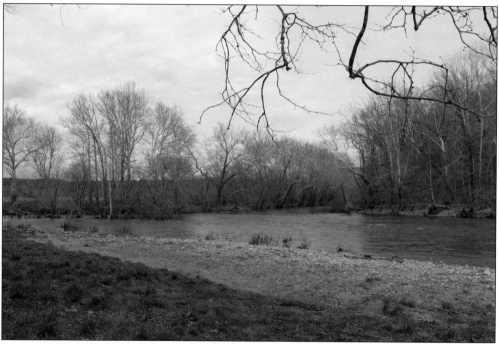

This peaceful place in Botetourt County, just south of Iron Gate, is the head of the James, at the confluence of the Jackson (left) and Cowpasture (right) Rivers. About 45 miles northwest of Iron Gate and just west of Hightown in Highland County, there is a divide between the James and Potomac watersheds. The ultimate source of the James is the Jackson, at Dividing Waters Farm, where a barn roof sheds water to the Jackson and James on one side and to the Potomac on the other. In his landmark 2001 book, *Journey on the James: Three Weeks through the Heart of Virginia*, reporter Earl Swift describes finding the inch-wide Jackson bubbling up from the ground. For the Norfolk *Virginian-Pilot*, he and photographer Ian Martin walked, drove, and canoed the entire length of the Jackson and James Rivers, from Hightown to the James's 4.4-mile-wide mouth at Newport News. Three years later, Dr. William E. Trout III produced his excellent *Upper James Atlas* for the Virginia Canals and Navigation Society. Following in their footsteps, this chapter will travel down the James River from Iron Gate to Newport News.

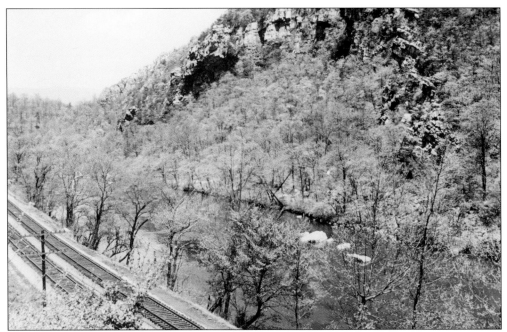

Between Clifton Forge and Iron Gate in Alleghany County, the Jackson River turns sharply to the south and passes through Rainbow Gap. This gap in the 900-foot-high mountains is named for Rainbow Rock, a 400-foot-high crescent-shaped arch of white rock in the steep mountainside. (Courtesy of the Daily Press, Inc.)

Iron Gate is a town on US 220, the Jackson River, and the CSX railroad, just above the head of the James. It was a center of the iron industry in the 19th century. East of the town, there is a water gap called Iron Gate that has iron deposits visible in its outcroppings. Iron Gate was named for it.

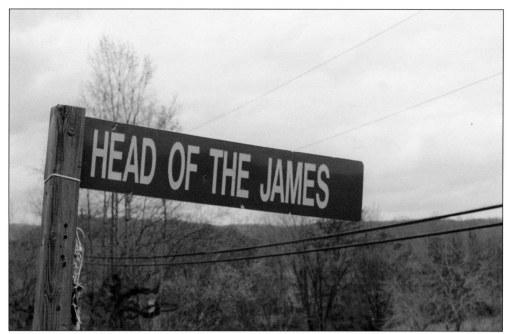

Head of the James Farm is a half-mile below Iron Gate. Here, the Jackson River joins with the Cowpasture River to form the James, which immediately makes a sharp turn to the south. The clean, bright Cowpasture has its origin in Bath County, about 32 miles north of here.

The 21-acre farm is located on US 220 between the CSX tracks and the rivers. It is owned by Charlie Gibson, whose family has been here for many generations. He is a very friendly man, proud of his farm and its location. Gibson mentioned that a large flood in 1985 brought the water up to the CSX tracks but stopped at the bottom of his floor joists. He said, "The Cowpasture is Virginia's only unpolluted river." And, modestly, "I don't know beans from potatoes." He very kindly allowed the author's wife and the author to walk down to the water.

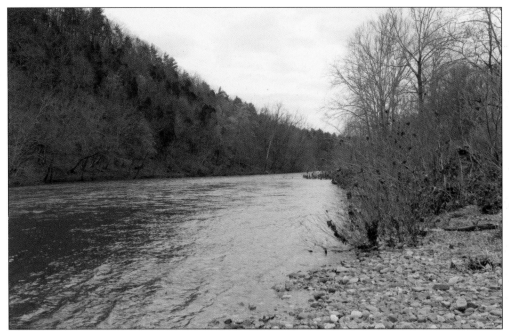

The junction of the Jackson and the Cowpasture Rivers to form the James is shown on page 67. The banks are strewn with small smooth stones, many purple in color, indicating the presence of iron. For those who love the river, it is a beautiful and almost sacred place. The James departs to the right and south, wider than the Jackson and the Cowpasture combined.

The community of Glen Wilton is about four miles from the head of the river, and Gala is seven miles farther. Sinking Creek and Mill Creek join the James here. This view is looking upriver and north from Gala. (Courtesy of the Daily Press, Inc.)

Next on the river is Eagle Rock, about 4.5 miles from Gala. Here was the end of the unfinished division of the James River and Kanawha Canal. The piers of an old highway bridge, shown here but now mostly gone, were made from stone salvaged from the last lock. (Courtesy of VCNS.)

Eagle Rock itself towers 1,060 feet over the town and river. It was formerly known as Eagle Mountain and Sheets. The CSX tracks run along the river in the foreground of this view looking upriver. The town of Eagle Rock is just out of view to the right.

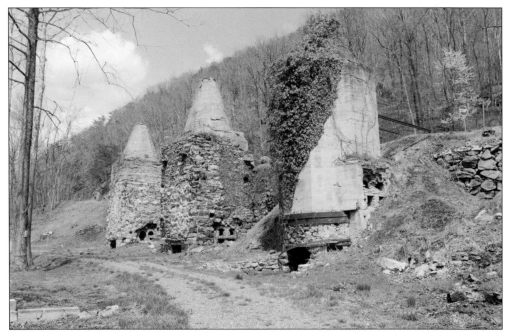

For those approaching Eagle Rock from the north, these abandoned lime kilns appear. Limestone was once transported across the river from lime quarries by cable and burned in the kilns to make lime. Nearby is Last Lock Park, built in 1976 by the Eagle Rock Garden Club as a memorial at the site of Lock 10.

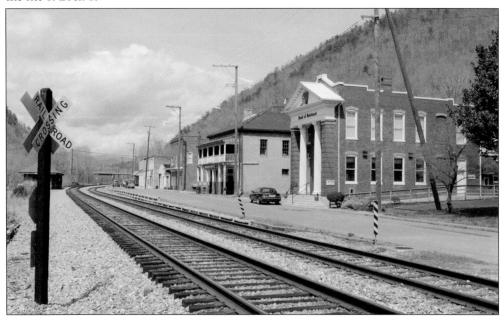

The quiet town of Eagle Rock, population about 2,200 (including the surrounding area), is situated across the CSX tracks from the James River. The largest structures here are the Bank of Botetourt and a former trackside hotel. The Eagle Rock Depot, seen in the background left, was a station on the C&O line between Clifton Forge and Lynchburg. Now, it is used by CSX for storage and maintenance.

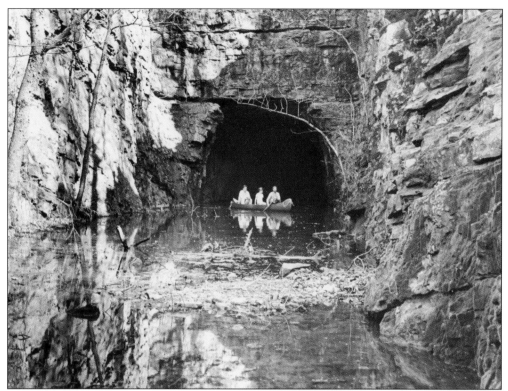

Downriver from Eagle Rock, the James River makes several very sharp bends. Horseshoe Bend, six miles below Eagle Rock, is the site of the unfinished 1,900-foot Marshall Tunnel, shown here. This tunnel was begun by the JR&K Company in 1856 to save building 2.5 miles of the canal. The state cut off funding, and the work was halted. (Courtesy of VCNS.)

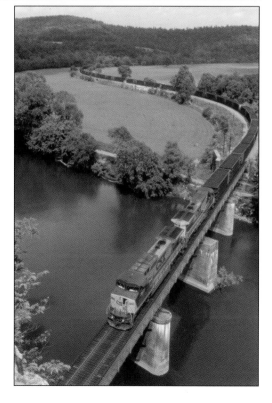

Three miles farther down the river is Mason Canal Tunnel, completed in 1856 in lieu of three miles of canal. The tunnel, three locks, and two sets of aqueduct piers were built. Later, the railroad laid track through the tunnel and used the piers for bridges. In this June 1996 view looking westward, a loaded CSX coal train is about to enter the now renamed Little Tunnel, just out of view at the bottom of the photograph. (Courtesy of Kurt R. Reisweber.)

Springwood, about two miles below Little Tunnel, was called Jackson in canal days. The James passes under I-81 three miles farther downstream before passing through Buchanan, two miles beyond. The river is fairly narrow at Buchanan, and the railroad is hidden by trees on its far bank. The river is often not visible from many river towns, with the raised railroad tracks running between the two.

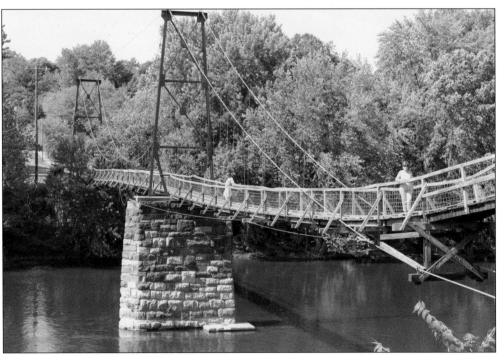

The 336-foot-long James River Suspension Bridge, now locally known as the "Swinging Bridge," crosses the James in the town of Buchanan, in Botetourt County. It was built in 1897 on the foundation of an 1851 covered bridge that was burned during the Civil War, rebuilt, swept away by a flood in 1877, and rebuilt again. In 1938, a concrete highway bridge was constructed, and the suspension bridge became a pedestrian crossing and local attraction.

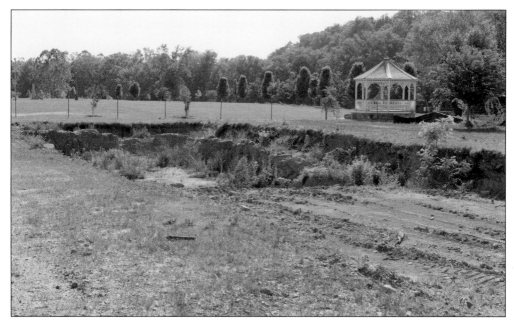

Buchanan was the western terminus of the canal. The old stone gauge dock there is shown being excavated. There were several gauge docks on the canal, to determine the tolls charged for its use. The weight of cargo was gauged by comparing the freeboard (the distance between the waterline and the deck) of each freight boat when loaded, compared to that when empty.

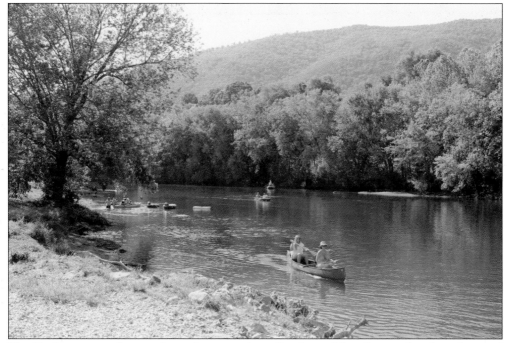

The Buchanan riverfront is shown here on a busy Sunday in May. Canoes, kayaks, tubes, and rafts abound. A public boat ramp is available, and a commercial outfitter offers both rentals and organized trips on the river.

Indian Rock is seven miles below Buchanan. There was a large dam here that was removed. Shown in this upriver view is a cable ferry, discontinued in 1953 after 70 years in service. (Courtesy of the Daily Press, Inc.)

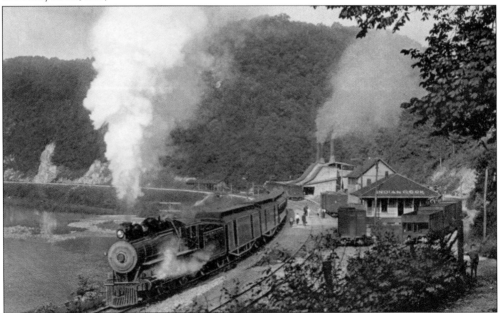

In this old postcard, a C&O passenger train is seen passing the Indian Rock depot. Sawmills and kilns are shown in the background. Down and across the river, the Indian Rock is an outcropping that, in profile, resembles the head of an Indian. (Courtesy of Kurt R. Reisweber.)

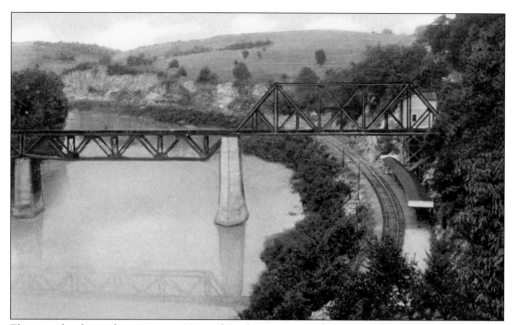

Eleven miles down the river were Natural Bridge Station and the Norfolk & Western rail bridge across the James. Natural Bridge itself is about 1.3 miles from the river and was reached by road from the station. (Courtesy of Kurt R. Reisweber.)

This peaceful view of the James River is looking downriver toward Glasgow. The Blue Ridge Mountains and turbulent Balcony Falls lie just ahead. (Courtesy of the Daily Press, Inc.)

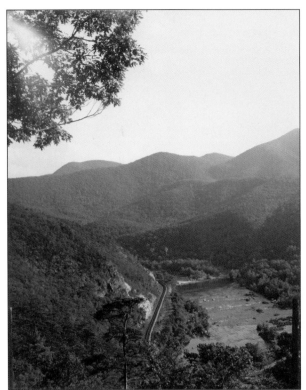

Also known as Water Gap and Blue Ridge Gorge, the James River Gorge is just downstream from the town of Glasgow, in Rockbridge County. Here, the James passes from the Mountain section into the Piedmont section of Virginia. The high steep mountains and rushing white water make this one of the most beautiful places on the river. The famous Balcony Falls and many rapids provide thrilling adventures for canoeists, and the roar of the rushing water is deafening. (Photograph by Royster Lyle, courtesy of VCNS.)

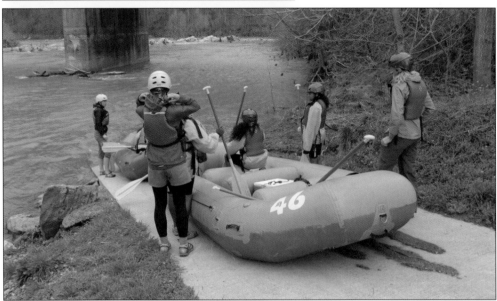

At Balcony Falls, the James River drops 11.5 feet per mile. The water rages and roars, and canoeing there through Class II and III rapids is not for beginners. On an April morning, the author met Marissa Wilterink of Urban Mountain Adventures, a Lynchburg nonprofit organization that takes urban and at-risk youth on exciting outdoor trips to challenge and broaden them. The organization was leading two rafts of teenage girls down the falls from Paget Park in Glasgow, and they were clearly "stoked."

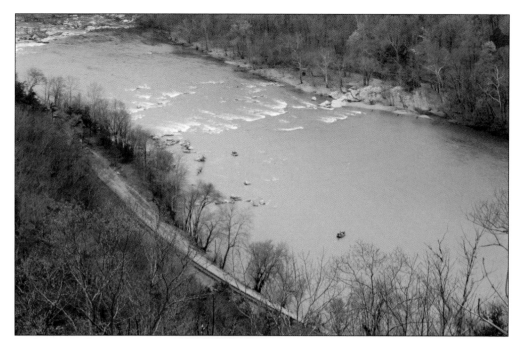

In the gorge, the railroad follows the river eastward on the old canal towpath. Route 501 climbs high up onto the mountainside and follows. Pictured at the Balcony Falls overlook, the two rafts enter Big Balcony Falls. The roar and power of the river are impressive, even from several hundred feet up.

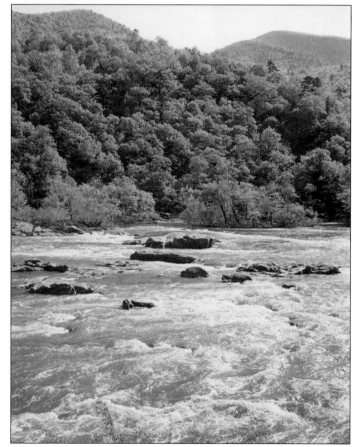

This low-level photograph of Balcony Falls accompanies the 1986 series The James: Virginia's River by reporter Bruce Ebert in the *Newport News Daily Press*. The power of the water is apparent here. Just three miles downriver, the Cushaw power plant dam calms the water and slows the flow. (Courtesy of the Daily Press, Inc.)

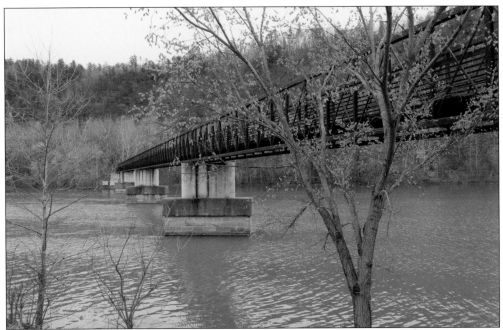

Just above the Cushaw power plant and dam, the railroad crosses the river diagonally on an old steel girder bridge. Adjacent is the 700-foot James River Foot Bridge, opened in 2000. This handsome Appalachian Trail bridge took two miles off the river crossing for hikers, who previously had to cross the James using the US 501 highway bridge.

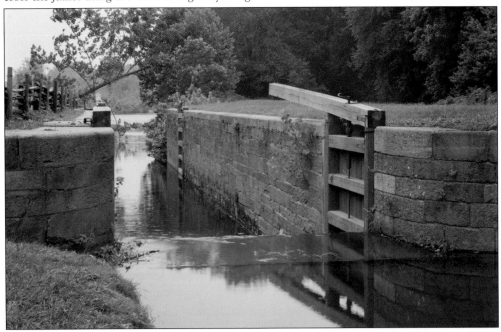

At the crest of the Blue Ridge and on the Blue Ridge Parkway, the National Park Service (NPS) restored the James River and Kanawha Canal's Battery Creek Lock in the 1960s. This lock operated between 1835 and 1880 and raised and lowered boats up to 13 feet. The reconstruction included the lock, operating gates, and an excellent visitor center. (Courtesy of the Library of Congress.)

Earl Swift notes in his 2001 book *Journey on the James* that, after Balcony Falls, he encountered "a river robbed" on the way to Lynchburg. He found the 27 miles of the river from there to Lynchburg spoiled by "seven dams and windswept pools" and industry, with virtually no place for portage of his canoe. This is a view of the river at Reed Creek, just below the Big Island Dam and a large paperboard plant, where river access could be found.

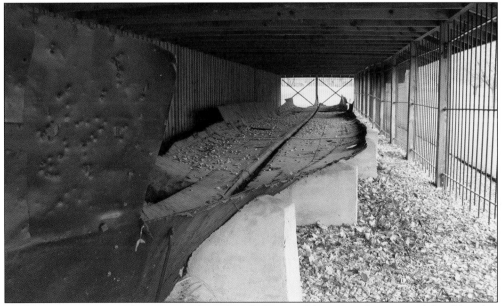

As the river enters Lynchburg, Riverside Park is the home of the restored remains of the old packet boat *Marshall*, once beached and used as a residence until it was washed away in a 1913 flood. Swift found its rusting hull displayed behind a chain-link fence in the park—not riverside, but on a high bluff with virtually no access to the river. The hull of the *Marshall* was later restored and provided with a protective shelter.

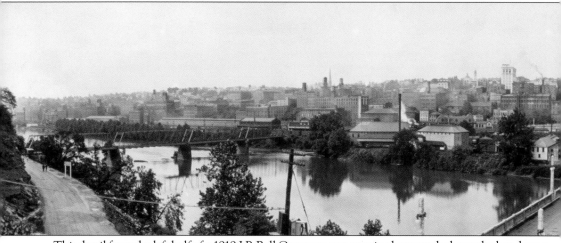

This detail from the left half of a 1919 J.P. Bell Company panoramic photograph shows the handsome and then new Williams Viaduct across the river at Fifth Street and the south end of the city. It replaced an iron bridge and a predecessor covered bridge that entered the city via Ninth Street. As seen, the city's riverfront was devoted to industry and the railroad. The right half of the 1919 panoramic photograph of Lynchburg shows the Williams Viaduct and north end of the city. The viaduct has since been replaced by a modern highway bridge. In 2001, Earl Swift observed that

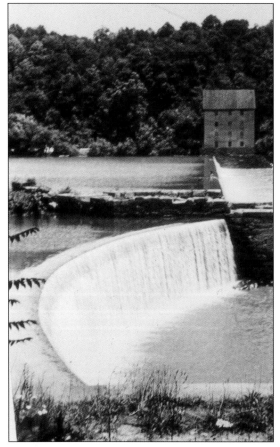

The 1846 curved waterworks dam and later Scotts Mill Dam just above Lynchburg are shown in this old photograph. There is a fish ladder, required by state law, between the two dams. The dams remain today. Remnants of the canal, including the stone bridge at Ninth Street, also survive. (Courtesy of Jones Memorial Library.)

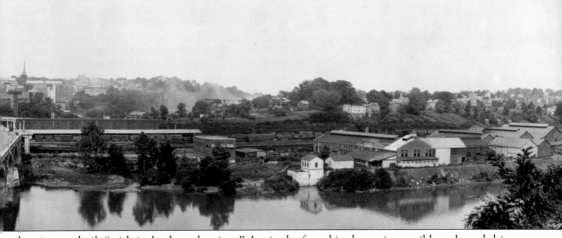

the city was built "with its back to the river." Again, he found it almost impossible to launch his canoe. But now, the 6.5-mile-long James River Heritage Trail takes hikers and bikers along the Blackwater Creek Bikeway and Riverwalk onto Percival's Island and over the river into Amherst County. There are public launching ramps on the river. (Courtesy of the Library of Congress.)

T. Gibson Hobbs Jr. (1917–2005) was a Lynchburg native and engineer who researched the James River and Kanawha Canal for 30 years. He carefully detailed the canal on topographic maps, uncovered and preserved its works, and cataloged a huge collection of images and information about its history. After Hobbs's passing, Nancy Blackwell Marion of Blackwell Press completed and published his beautiful book, *The Canal on the James*, in 2009. Hobbs's collection is at the Jones Memorial Library in Lynchburg. (Courtesy of Jones Memorial Library.)

William E. "Bill" Trout III, PhD, now of Madison Heights, is in the American Canal Society's Canal Buffs Hall of Fame. He is a cofounder, trustee, and past president of the American Canal Society and the Virginia Canals and Navigations Society. During a career in biology and genetics, Trout became interested in canals and canal lore of the 1950s. He "retired" in 1983 and, with the support of his late wife, Nancy, wrote countless articles on canal history along with a renowned series of canal and river atlases. (Photograph by Kevin Page, courtesy of VCNS.)

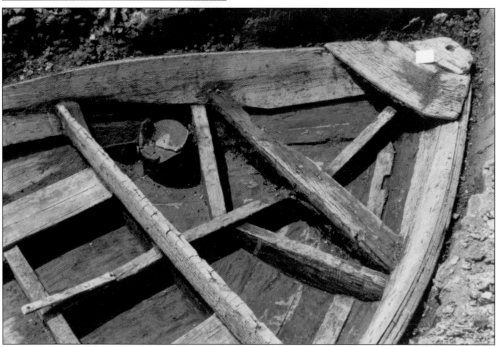

In 1983, a James River batteau was rediscovered. A deep hole where the Great Basin had been was being excavated for a new office complex in Richmond. Luckily, James Moore III and Dr. Bill Trout were watching. That August, the hull of an iron packet boat was uncovered, then a batteau, then the *Hearth Boat*, pictured. Over the next two years, many other boats were discovered. These remains were carefully studied, and many were preserved. The *Hearth Boat* was named for its stone hearth surrounded by bricks. (Photograph by Dr. Bill Trout, courtesy of VCNS.)

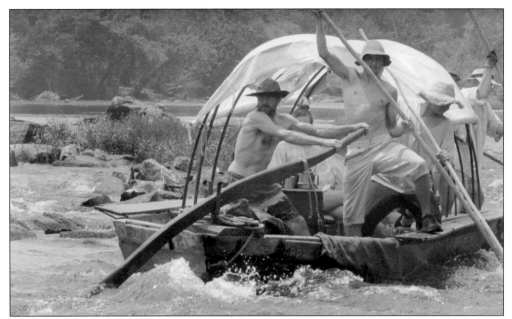

Following the discoveries in Richmond, Ben Saunders and Joe Ayers built the *Columbia*, the first James River batteau in modern times. This motivated others, and in May 1986, the first James River Batteau Festival was launched, with 10 boats floating from Lynchburg almost to Richmond. The batteau *Rose of Nelson* is shown participating in the 2010 festival. (Photograph by Philip deVos, courtesy of VCNS.)

The batteaux *Peak Shadow*, *Chesterfield*, *New London*, *Warick*, *Hope*, and *Maidens* are shown at rest during the 2009 festival. When not in use, these vessels are typically stored underwater in ponds to maintain their watertightness. (Photograph by Philip deVos, courtesy of VCNS.)

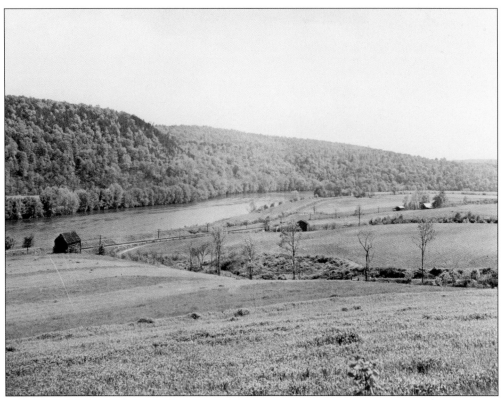

This view of rolling hills along the river is looking upstream from Riverville, 23 miles downriver from Lynchburg. (Courtesy of the Daily Press, Inc.)

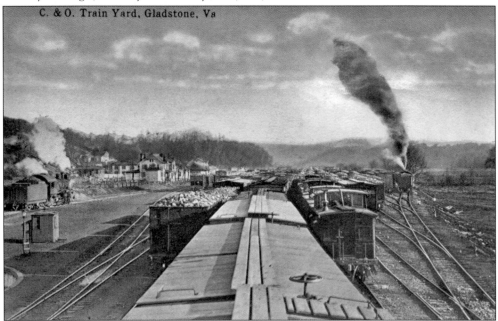

C. & O. Train Yard, Gladstone, Va

On this old postcard, the C&O train yard at Gladstone in the early 1900s is seen in this eastward view from the top of a boxcar. (Courtesy of COHS.)

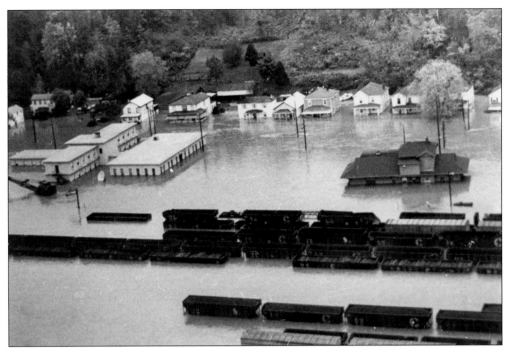

C&O facilities and equipment at Gladstone were inundated during a flood in November 1985. The depot and the new YMCA building, office buildings, and homes, as well as many railcars, are shown in the water. (Courtesy of COHS.)

This peaceful scene is at the 1,651-acre James River State Park in Buckingham County, created by the Virginia Department of Historic Resources after 2002. It lies on a large bend in the river, across from the community of Norwood, in Nelson County.

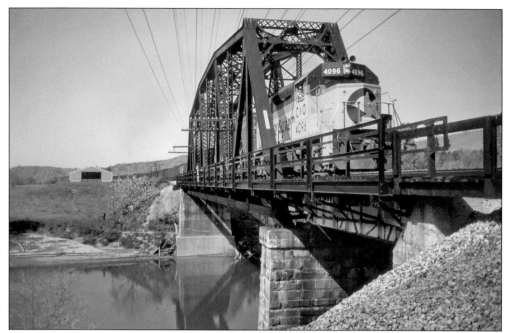

Chessie System locomotive 4096 has left Gladstone and is crossing the Tye River Bridge at Norwood in May 1969. The stone bridge piers date to the canal period. The C&O became part of the Chessie System in 1973 and then CSX Transportation in 1980. (Photograph by Gene Huddleston, courtesy of COHS.)

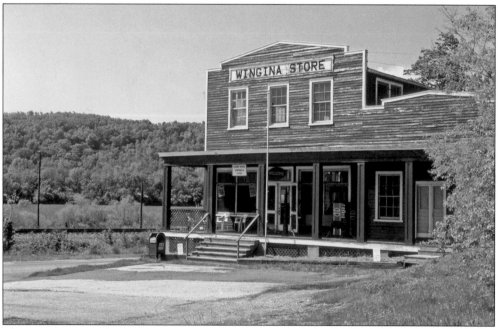

The James River and railroad appear beyond Wingina Store in this May 1998 view. It is said that the tiny village was named for Indian chief Wingina, who greeted the English settlers when they arrived on the Outer Banks in 1581. But no one knows why that name was chosen. (Photograph by Gene Huddleston, courtesy of COHS.)

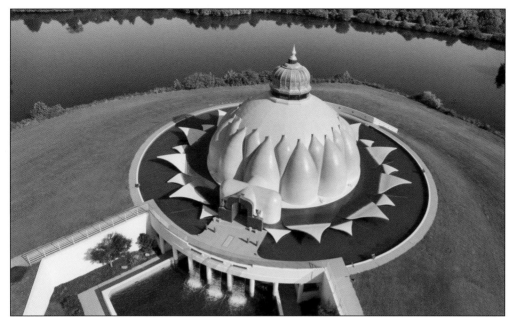

Yogaville, near the James River in Buckingham County, is "a vibrant spiritual community" built on the precepts of Integral Yoga as taught by Sri Swami Satchidananda. Opened in 1986, the colorful LOTUS (Light Of Truth Universal Shrine) is an ecumenical meditation hall dedicated to world peace. All are welcome to visit. The highest point on the Yogaville property is known as Kailash, named after the holy abode of Lord Siva in the Himalayas. It has panoramic views of the Blue Ridge Mountains in the distance. (Courtesy of Yogaville.)

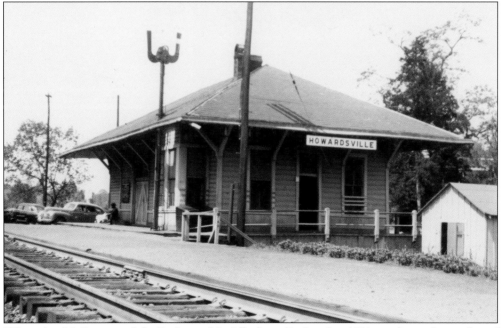

When the C&O acquired the Richmond & Alleghany Railroad in 1890, it inherited a number of depots. This one at Howardsville is a good example of an R&A-style station with hipped roof, large eaves overhanging, and squared bay window. (Photograph by W.H. Odell, courtesy of COHS.)

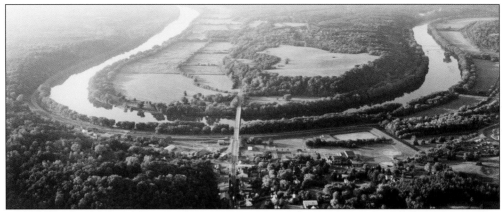

Scottsville is situated on the northernmost point in the James River by a magnificent horseshoe bend. Canal Square is a major outdoor museum devoted to the history of the James River and Kanawha Canal. This stunning aerial photograph was taken by Robert Llewellyn around 1990. (Courtesy of Scottsville Museum.)

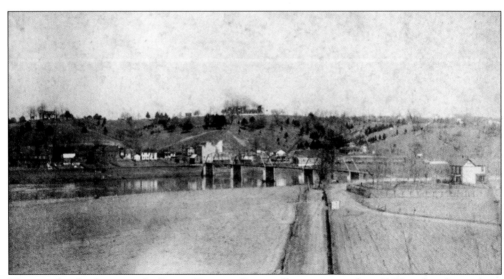

The wooden bridge over the James River at Scottsville was erected in 1907 and is shown here from the Buckingham County side of the river. The bridge replaced the 162-year-old Scottsville Ferry, and soon horses and buggies along with automobiles clattered together across its wooden planks. (Photograph and caption courtesy of Scottsville Museum.)

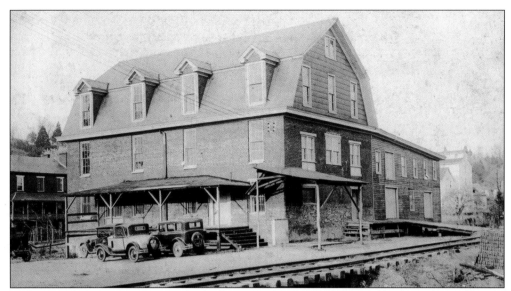

Built around 1834–1844, the Canal Warehouse is a large, gambrel-roofed building, located on the former James River and Kanawha Canal in Scottsville. While river and canal traffic flourished, the warehouse was full of tobacco, grain, and other produce waiting to be shipped to Richmond markets. Scottsville used this building on South Street for many different purposes after the canal's demise in 1880. During the 1940s, the old Canal Warehouse even served as a much-loved social center for Scottsville. It is currently undergoing historic reconstruction and restoration. (Photograph and caption courtesy of Scottsville Museum.)

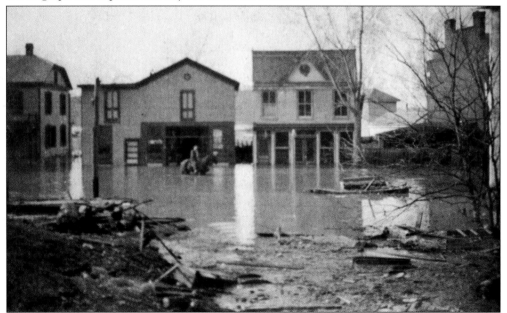

Since 1870, Scottsville has experienced 21 floods of 20 feet or more above mean low water level. Floodwaters and mud have rolled into town, devastating businesses and homes in their path. This is a view of the March 1913 flood; at 20.16 feet, it was the eighth-greatest flood in Scottsville's history. Hurricane Agnes struck with disastrous results on June 22, 1972, with a record of 34.02 feet. (Photograph and caption courtesy of Scottsville Museum.)

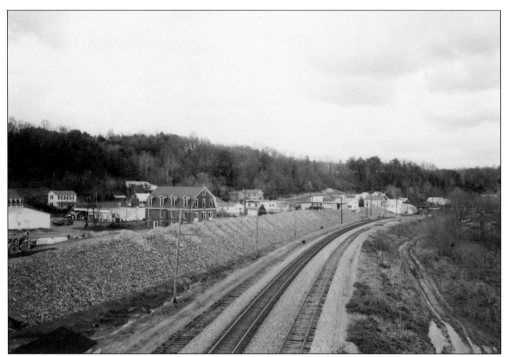

After Hurricane Agnes, Mayor A. Raymon Thacker led a campaign to build a protective levee. In 1985, the Army Corps of Engineers built the levee around the lowest portion of Scottsville to prevent any more floods. (Photograph by Geneva Denby, courtesy of Scottsville Museum.)

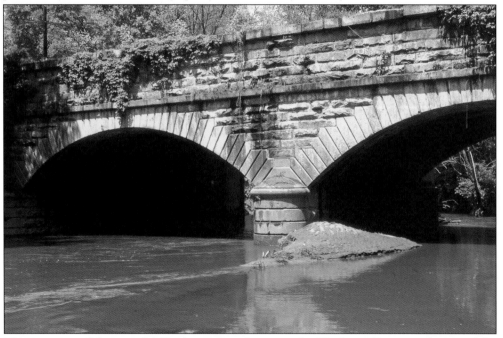

This is a view of the graceful Hardware Aqueduct over the Hardware River, a tributary of the James, in Fluvanna County, about 73 miles west of Richmond. It now serves as a CSX railroad bridge. (Photograph by Gene Huddleston, courtesy of COHS.)

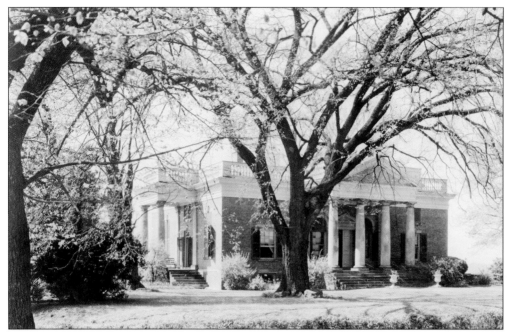

The Bremo Bluff mansion is located high above the river at Bremo Bluff, in Fluvanna County, 68 miles west of Richmond. In 1639, Richard Cocke patented acreage on the James River in present-day Henrico County. Around 1689, the family moved here, and Richard Cocke's son John built this home. There now is a large tree farm in this area. (Courtesy of the Library of Congress.)

The mouth of the Rivanna River is located at Columbia, on the north bank of the James, 57 miles west of Richmond. The Rivanna Connection Canal was built in the 1850s to facilitate batteau navigation on the Rivanna north to Charlottesville. The graceful Columbia Aqueduct was demolished by the C&O in the 1940s.

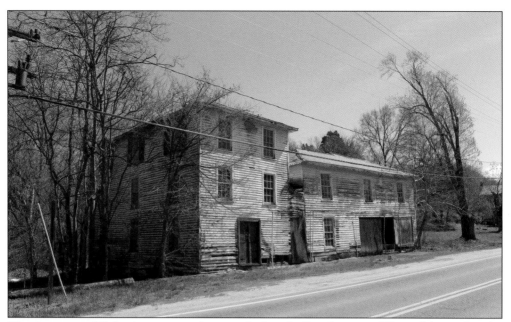

The tiny town of Columbia was a trading post before the Revolutionary War and, located at the intersection of two canals, it thrived during the canal era. The railroad brought prosperity to the area after the Civil War, and it continued until the late 1950s. Then, passenger and mail train service ended, freight declined, and the town was almost destroyed by floods.

Columbia, population 49 in 2000, was the smallest incorporated town in Virginia. In 2014, it was placed on Preservation Virginia's "most endangered list." Despite Columbia's current shabby appearance, the Foundation for Columbia's Future is dedicated to preserving the historic river town. Citizens voted on March 17, 2015, to disincorporate the town and become part of Fluvanna County.

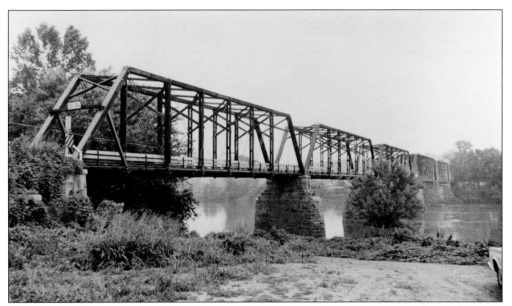

In Cumberland County on the south bank of the James 47 miles from Richmond, Cartersville was originally just a tavern and a wharf during canal days. The picturesque town is now an overnight stop for the James River Batteau Festival and has a historic district and several National Register of Historic Places properties. The remains of the 1884 bridge, shown here but destroyed by Hurricane Agnes in 1972, were saved by the Cartersville Historic Bridge Association. (Courtesy of the Library of Congress.)

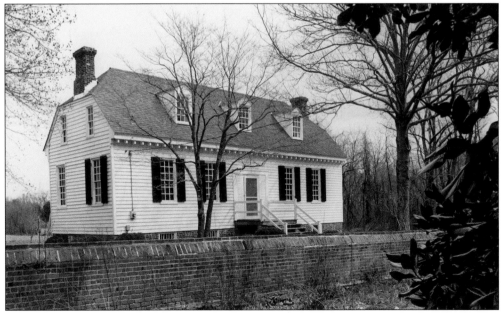

Rock Castle, now known as the Queen Anne Cottage, is situated on a high bluff over the James River that is named Rock Castle, in Goochland County, 40 miles from Richmond. It was built by Tarleton Fleming in 1750. In 1935, the house was moved to its present location on the property, and a large Norman manor-style house was erected on its original site. Rock Castle Falls lie in the river below the bluff. (Courtesy of Virginia Department of Historic Resources.)

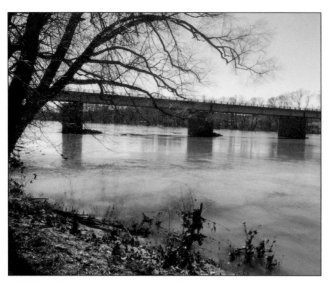

The public boat landing at Maidens Bridge, 31 miles above Richmond, is the terminus of the weeklong James River Batteau Festival. Maidens was originally known as Maiden's Adventure, named for the legend of a young girl who crossed the James River to warn her lover of an impending Indian attack. Just downriver is Manakin-Sabot, where French Huguenot refugees settled and prospered in 1700. The name Sabot Island was given to the large island formed by two creeks and shaped like a wooden shoe (*sabot* in French).

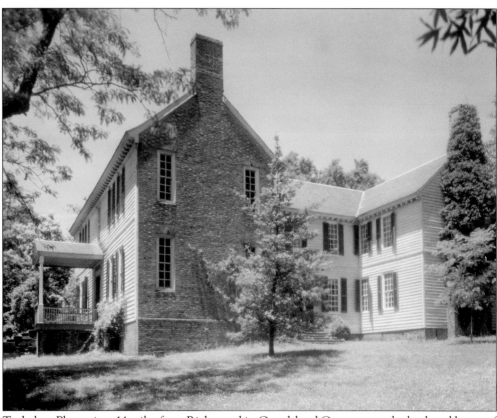

Tuckahoe Plantation, 14 miles from Richmond in Goochland County, was the boyhood home of Thomas Jefferson. When widower William Randolph died in 1747, his friend Peter Jefferson was named guardian of his children, and the Jefferson family lived there until 1754. In the early 1800s, coal was carried down Upper Tuckahoe Creek by batteaux from the Richmond Coal Fields. Later, its east branch became the main line on the canal. (Courtesy of the Library of Congress.)

Bosher's Dam, nine miles above Richmond, was built in 1828 and rebuilt in 1835. It still serves its original purpose as a feeder dam that supplies the canal leading into Richmond. In 1999, a fishway was installed at Bosher's Dam to enable fish to reach the Upper James for the first time in almost 200 years. The Virginia Department of Game and Inland Fisheries website at www.dgif. virginia.gov/fishing/shadcam/ provides an online "Shad Cam" view of their passage from late March to early June. (Courtesy of Dennis Danvers.)

The City of Richmond developed James River Park, a 550-acre, 7.5-mile park on both sides of the James River from Huguenot Woods in the west to Ancarrow's Landing in the east. It has been called "an area of unspoiled beauty unlike that found in any other city in the country." There is canoe access into relatively flat water at Huguenot Woods, shown here on a warm spring Saturday. The park is often full of visitors enjoying the river.

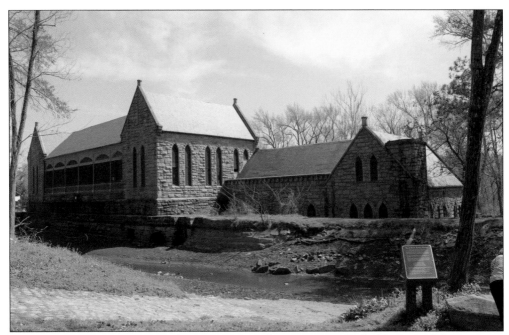

The 1881 Pump House is now the centerpiece of Pump House Park. Unrestored, but open to visitors, it is interpreted by Lyn Lanier and other VCNS volunteers, who hope to restore it as the Virginia Canal Museum. Remnants of three canals—the James River, the James River and Kanawha, and the Pump House—are visible here.

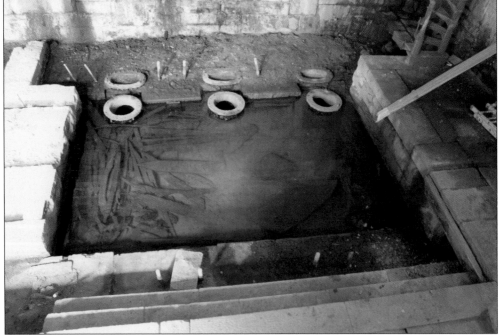

The ground floor of the Pump House held water-powered pumps, which were sold to Japan as scrap before World War II. The pump pits were later flooded and now preserve artifacts recovered during the Great Basin Excavation of 1983–1985.

This view of the James River in Richmond, near the graves of presidents James Monroe and John Tyler, is looking southwest and upriver from Hollywood Cemetery. The river is turbulent here, and the far shore is filled with visitors to the James River Park. In the foreground, the CSX James River line is visible.

In this view looking downriver and east from Hollywood Cemetery, the 1987 Robert E. Lee Bridge and downtown Richmond can be seen. One of the largest flood-protection systems in the nation was completed in 1994, opening miles of the James River to public access, with river walks, trails, and scenic overlooks. The total length of the floodwall is 3.2 miles, with 1.2 miles on the north shore of the James River and two miles on the south bank. The construction of the floodwall was spurred by eight major floods in Richmond between 1969 and 1987. It is designed to protect Richmond from floods of up to 32 feet, which would have stopped all of the recorded floods except during Hurricane Agnes, which hit 36.5 feet on June 23, 1972.

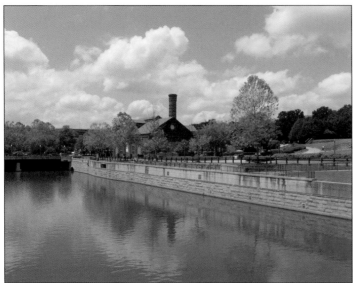

Tredegar Iron Works escaped destruction during the evacuation of Richmond in April 1865 and stayed in business until the 1950s. In 2007, it was opened to the public as the American Civil War Center at Historic Tredegar. A pedestrian suspension bridge takes visitors from there to Belle Isle.

Brown's Island, just below Tredegar, was the site of a munitions plant that exploded on February 13, 1863, killing 30 female workers. The island was restored by Richmond Renaissance and is now part of the Canal Walk, connected to the riverbank by a footbridge. The main feature on Brown's Island is heroic statue *The Headman* by Paul DiPasquale. The original fiberglass statue was dedicated in 1988, but it was stolen and destroyed. In 1992, a new bronze statue was installed, standing on the stern of a batteau and protected by an iron fence. Its inspiring plaque reads: "The Headman: Commemorates the contributions of African American men as skilled boatmen on the James River and its canals, and in the development of industry in the City of Richmond." The monument was chosen as the subject for the redesign of the city's flag, which now depicts a boatman in red, white, and blue.

Much of the canal has been restored in downtown Richmond, including the Haxhall Canal from Tredegar Iron Works to Twelfth Street and the James River and Kanawha Canal from Twelfth Street to the Triple Crossing at Tidewater Connection. It is now known as the Canal Walk, a lively urban area for recreation, dining, and history. River district canal cruises on 35-passenger canalboats are offered in season. (Courtesy of Venture Richmond.)

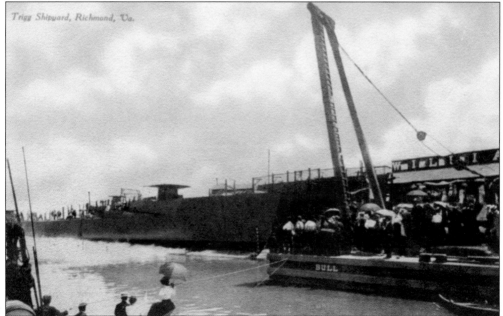

Founded by William R. Trigg in 1899, the Trigg Shipbuilding Company was located on Chappell Island near the Great Ship Lock. Two torpedo boats were built for the Navy, and the first of these, USS *Shubrick*, was launched in 1900 with President McKinley, his cabinet, and 30,000 spectators in attendance. Unfortunately, the company went into receivership, and Trigg died in 1902. Remnants of the shipyard and parts of its lock have recently been uncovered and interpreted. (Courtesy of the Library of Virginia.)

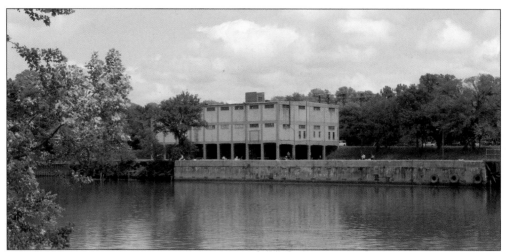

The Richmond Intermediate Terminal, just downriver from the Great Ship Lock, was built in 1937, along with an adjacent warehouse that was demolished in 2009. Small ships would load and unload here; a million and a half tons were transferred in 1939. Cargo was mainly sugar and tobacco coming in (the raw sugar was mostly used to make cigarettes) and refined sugar and scrap iron going out. The dinner cruise boat *Annabel Lee* sailed from here from 1988 until January 2004. Now, the site is occasionally used as a concert and event venue. Some think it has development potential.

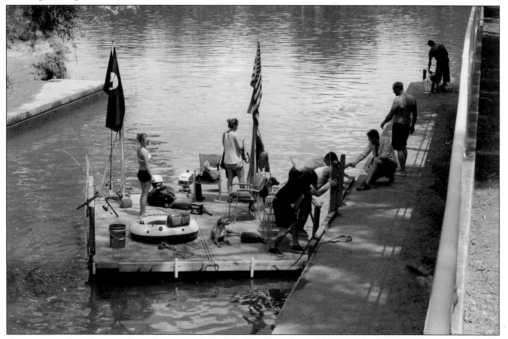

Ancarrow's Landing is directly across from the Intermediate Terminal. It was named for Newton Ancarrow, an engineer, environmental activist, and builder of luxury speedboats in the 1960s. Ancarrow Marine's large concrete boat ramp is now part of the James River Park system. This creative craft and its crew are pictured on a spring Saturday, returning from a cruise on the river. Owned by Nate Story and Keith Henderson, the vessel is a retired floating dock powered by an outboard motor and flying the Jolly Roger.

Rocketts, so important during the Civil War, later became an industrial area and railroad yard. The C&O and Richmond Cedar Works had major operations there until a few decades ago. Now, the area and its industrial buildings have been developed into a large, upscale urban community on the James. The floating piers of a marina line the shore, and the Cedar Works is a luxury condominium building. The James River Association is now headquartered there. This view is looking upriver from Rocketts Landing to downtown Richmond.

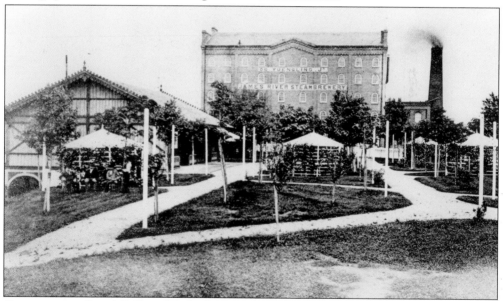

German native David G. Yuengling built a brewery at Pottstown, Pennsylvania, in 1829. His son, David Jr., built a second one on the river at Rocketts around 1850, naming it the James River Steam Brewery. Others were built in New York and Canada, but they were all closed around 1900. This photograph shows the brewery with a beer garden in the foreground. Ruins of this brewery still exist, and there has been talk of returning it to its former purpose. (Courtesy of the Library of Virginia.)

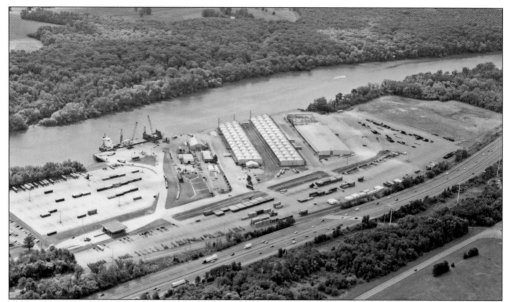

The Port of Richmond, also known as Richmond Deepwater Terminal, is located in Henrico County five miles below Rocketts. Managed by the Virginia Port Authority, it is 78 miles from Hampton Roads. The port has 121 total acres and 34 acres of open storage as well as 300,105 square feet of warehouse capacity. Its dock apron is 1,584 feet long and depth is 25 feet. The port is convenient to CSX and Norfolk Southern (via local switch service) and I-95, I-64, and I-85. (Courtesy of the West Cary Group.)

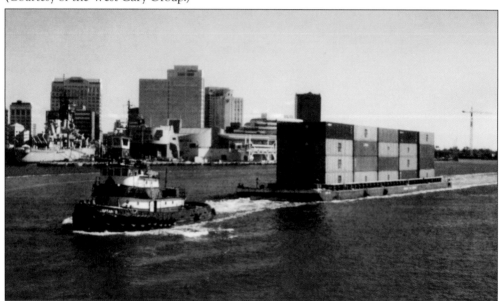

The 64 Express is a barge service that offers triweekly container service between Richmond and Hampton Roads. The James River Barge Line initiated tug and barge container service on December 1, 2008, leapfrogging the congested roadways that delay international cargo. Thrice weekly service was initiated in December 2013, with a capacity of 600 forty-foot containers per week. Primarily, cargoes are paper-and-wood-related products for export and tobacco for imports. Transit time is about 12 hours. (Courtesy of 64 Express.)

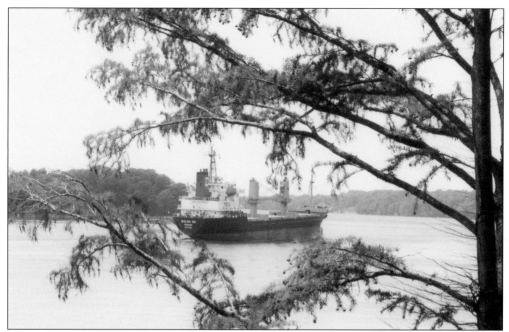

This small cargo ship is sailing downriver at Fort Powhatan, about 14 miles below Hopewell. At a narrow bend to the left is 90-foot-deep Weyanoke Point, the deepest point anywhere on the river. The ship is running light, probably having unloaded bulk cargo at Hopewell. It is typical of the medium-sized, foreign-flagged freighters now seen on the river. (Courtesy of Will Molineux.)

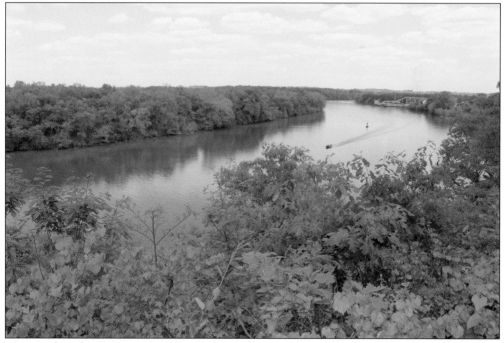

This modern look down the James from Drewry's Bluff shows the imposing view from the Confederate battery there during the Civil War. In fact, a huge, 8-inch gun is on display just out of the picture to the right. The site is now part of the Richmond National Battlefield Park.

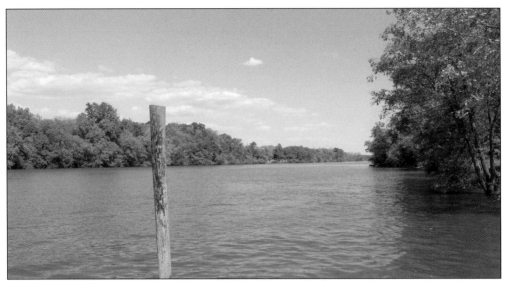

The Dutch Gap Cutoff is seen, in a view looking downriver. There is a public boat ramp here, and it is busy on a Sunday afternoon. The huge Chesterfield Power Plant is just upriver, and Henricus Historical Park is close by. Hatcher Island, the river bend cutoff by Dutch Gap, is across the river on the left.

The Richmond Yacht Basin is located on the cutoff river north of Hatcher Island. It is an interesting place, with many older boats and friendly people. One of these was the author's late friend Bill Poole. He is shown working on his antique boat, the 48-foot *Katie*, which was built in 1915 and served the Navy in World War I. Poole purchased it in 1963 and used it both as a private yacht and a Coast Guard auxiliary craft for many years. Poole was born in east Richmond and lived for the river. (Courtesy of William C. Poole Jr.)

This peaceful 1860s image shows fishermen on the James at Bermuda Hundred, located in Chesterfield County on the south bank, a mile above City Point. It was named by Gov. Sir Thomas Gates, who was shipwrecked on Bermuda en route to Virginia. Bermuda Hundred was settled in 1613 but was wiped out by the Massacre of 1622. It is now occupied by a large nylon resin plant. (Courtesy of the Library of Congress.)

Appomattox Manor is located at City Point, at the mouth of the Appomattox River. The point was patented in 1635 by Capt. Francis Eppes, who by tradition came in the ship *Hopewell*. He built a home named Eppington, which was replaced with Appomattox Manor by his grandson in 1751. It became Ulysses S. Grant's headquarters in 1864 and is now managed by the National Park Service and open to the public. (Courtesy of the Library of Congress.)

In 1911, DuPont purchased land from an Eppes descendant and built a dynamite plant at Hopewell. When World War I began in 1914, this plant was enlarged to make guncotton. By 1915, Hopewell had a population of over 40,000 and became a lawless boomtown. Destroyed by a fire in 1915 and rebuilt, the plant was closed in 1919. DuPont reopened the plant during World War II, and others were built nearby. Criminal dumping of the dangerous insecticide Kepone from a Hopewell plant in the 1960s and 1970s led to the 1975 closing of 100 miles of the river to fishing for 13 years.

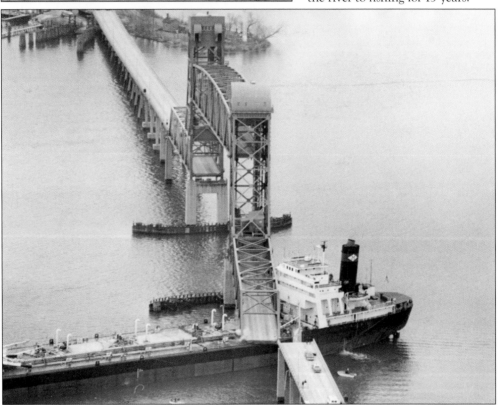

The 612-foot sulphur tanker *Marine Floridian* struck the Benjamin Harrison Memorial Bridge at Jordan's Point, below Hopewell, at 7:00 a.m. on February 24, 1977, which became known locally as "the day that the ship hit the span." While viewing the impending collision, commuters waiting on the drawbridge ran for their lives, and four cars fell into the river, though no one was injured or killed. Part of the bridge collapsed onto the deck of the ship. The cause of the accident was a steering gear failure aboard the ship. A ferry service was provided for many months while the bridge was repaired. (Courtesy of the Daily Press, Inc.)

In 1726, Berkeley Plantation was built by Benjamin Harrison in Charles City County on the north shore of the river below Hopewell. His son, Col. Benjamin Harrison, was a signer of the Declaration of Independence. In 1773, Pres. William Henry Harrison was born at Berkeley, making him the last president to be born as a British subject. Today, the mansion is privately owned and open to the public. (Courtesy of the Daily Press, Inc.)

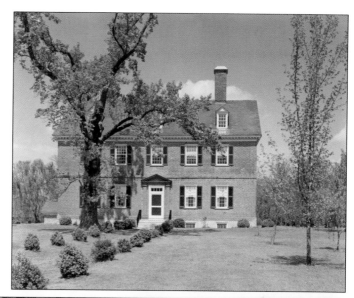

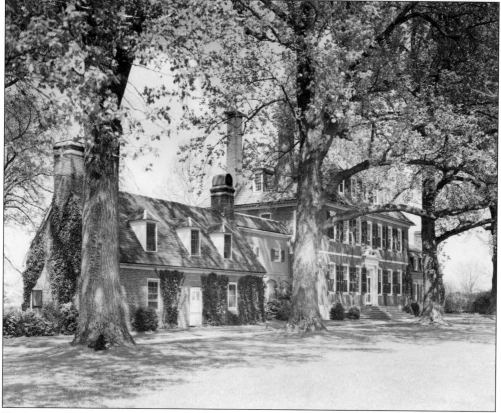

Westover, magnificently situated on the river, is just over a mile downriver from Berkeley. It was built by William Byrd III, the founder of Richmond, in 1730–1732. British general Benedict Arnold landed 1,600 troops here before his attack on Richmond in January 1781. The mansion is now privately owned, and except for its gardens, is normally closed to the public. (Courtesy of the Daily Press, Inc.)

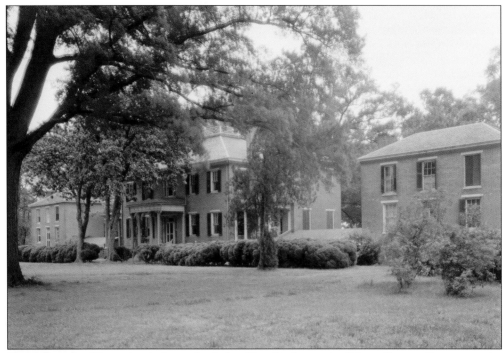

Upper Brandon Plantation is five miles below Fort Powhatan, in Prince George County on the south shore of the James. The land was first settled in 1610 by John Martin, who built houses and imported settlers there. After he died in 1632, Martin's land was sold. In 1720, it was purchased by Nathaniel Harrison, whose son Nathaniel II inherited it and built the mansion. It remained in the Harrison family until 1948. In 1984, a major corporation purchased it and restored the house. Later sold to a private owner, Upper Brandon continues as a working farm. (Courtesy of the Library of Congress.)

The land at Claremont, in Surry County, was not patented until 1649. Arthur Allen built a house here and also built Bacon's Castle, 17 miles to the southeast. His son, John Allen, built Claremont Manor around 1750. The property was owned by the Allen family for 205 years until it was sold off in small tracts in 1879. The narrow gauge Atlantic & Danville Railway came in 1886, and Claremont became a prosperous river port and town. But the railroad subsequently was relocated, the steamboat era ended, and the town declined. Today, Claremont is a popular retreat and resort. Claremont Manor is privately owned and closed to the public. (Courtesy of the Library of Congress.)

Jamestown Island became farmland and forest after the capital moved to Williamsburg in 1699. In years ending in '07 and '57, the 1607 settlement was commemorated there. The Jamestown Exposition, held in Norfolk in 1907, was particularly notable. In 1893, twenty-two and a half acres of land, including the old church tower, were given to the Association for the Preservation of Virginia Antiquities (APVA). The rest of the island was acquired in 1934 for Colonial National Historical Park. For the 1957 commemoration, the Colonial Parkway, built in the 1930s, was extended from Williamsburg to Jamestown across a newly created land bridge to the island, shown here. (Courtesy of the Daily Press, Inc.)

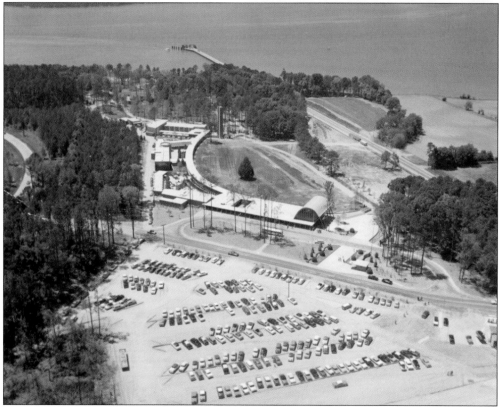

Opening on April 1, 1957, Jamestown Festival Park was built at Glass House Point on the mainland as a state-owned museum complex with a re-created James Fort, Native Village, and replicas of Jamestown ships. For its 400th anniversary in 2007, the site was renamed Jamestown Settlement and greatly improved and expanded. New museums and replica ships were built. In 1956, the Jamestown-Scotland Ferry terminal was moved from Jamestown Island to a new site on the mainland, shown at the top of the photograph. (Courtesy of the Daily Press, Inc.)

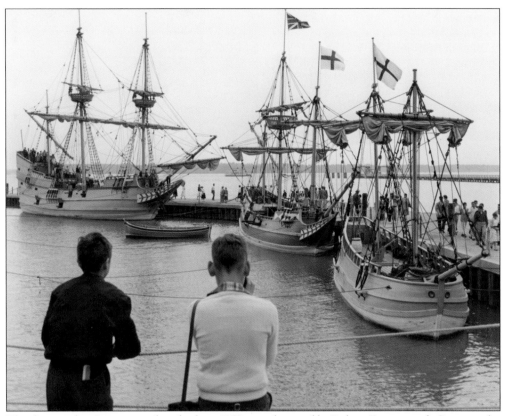

The three replica Jamestown ships built in 1957 were designed by Robert Fee to match Commander Coale's painting, shown on page 9. They were built at Dunn's Marine Railway at West Norfolk and added greatly to the success of the Jamestown Festival. In 1984, another replica of the *Godspeed* was built at Jamestown under the direction of volunteer Lester Sweeny. This *Godspeed* was transported to England aboard a container ship and sailed to Jamestown by a volunteer crew, arriving home on October 22, 1985. (Courtesy of the Daily Press, Inc.)

In the early 1990s, in anticipation of the 400th anniversary of the landing at Jamestown, the NPS and APVA (now Preservation Virginia) launched an extensive archaeological assessment and research project, all to address the under-explored 17th-century site. NPS conducted an assessment of its massive collections from the region and Preservation Virginia initiated its Jamestown Rediscovery project to search for the original 1607 fort, thought long-lost to the James River. Under the leadership of Dr. William Kelso, significant discoveries were made, and the original fort, buildings, and remains of settlers were uncovered.

The Jamestown-Scotland Ferry was founded by Capt. Albert F. Jester in 1925. He was the owner and operator of the Smithfield-to-Newport News passenger and mail boat *Onetia*. In 1925, there was no way to cross the James River between Richmond and Norfolk. Captain Jester operated the ferry until it was sold to the Virginia Department of Highways (now VDOT) in 1945. Pictured is a 1982 view of the Scotland terminal, in Surry County. (Courtesy of the Daily Press, Inc.)

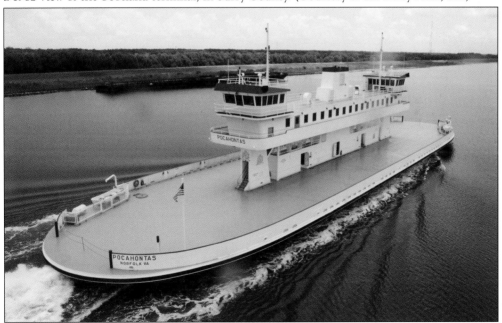

In 1995, the 90-car *Pocahontas* was built in Mississippi by Moss Point Marine, now a division of VT Halter Marine. It is the 14th ferry on the Jamestown-Scotland run since 1925. The ferry system succeeded beyond Captain Jester's wildest dreams. Now operated by VDOT, it is free and runs 24 hours a day as part of Route 31. The current four-boat fleet also includes the 50-car *Williamsburg* (1983), *Surry* (1979), and the smaller *Virginia* (1936). In a recent year, over one million vehicles were transported across the river. (Courtesy of VDOT.)

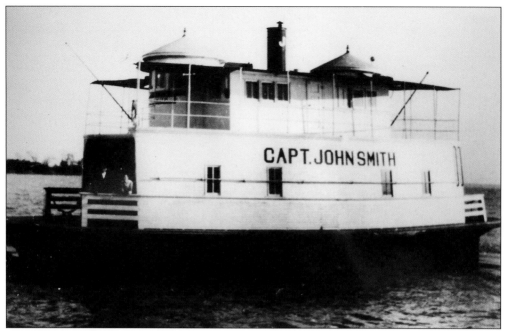

The 65-foot, double-ended wooden ferry *Capt. John Smith* was built for Captain Jester at Battery Park, near Smithfield. It had a 60-horsepower engine and could carry 16 Model Ts and 100 passengers. On February 26, 1925, the *Capt. John Smith* entered service between Jamestown and Scotland as the first modern ferry on the James River. After the ferry system was sold in 1945, the upper deckhouse was removed. The ferry remained in service for a few more years, until it was sold and then abandoned in the 1950s. Its hull was briefly used by Bill Poole as a floating marina in the Richmond canal. (Author's collection.)

The 20-by-30-foot deckhouse was salvaged by Fred W. Beazley of Portsmouth and became a summer cottage on pilings at his farm on the Western Branch Elizabeth River in 1946. Apparently, it was later used as a chicken house before being abandoned after Beazley's death in 1974. The abandoned structure was recovered, moved to Surry, and donated to the Surry County Historical Society in 2005. After funds were raised, it was restored as a museum and opened to visitors in May 2015.

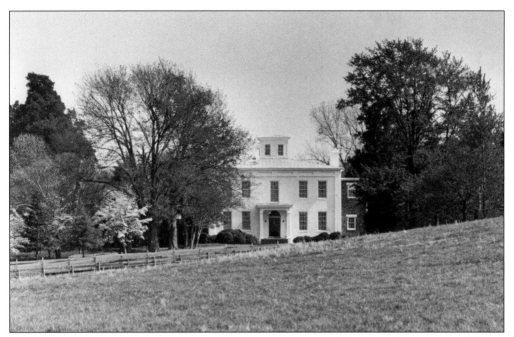

Chippokes Plantation, just upriver from Hog Island, was established in 1617 by Capt. William Powell. The plantation was donated to the Commonwealth of Virginia by Evelyn Stewart for use as a state park in 1967. It has been a working farm since the 17th century and remains as an example of life in that simpler era. The Pork, Peanut, & Pine Festival is held there every July, celebrating Surry County's most important products. (Courtesy of the Daily Press, Inc.)

Seventeenth-century settlers kept their hogs on 2,000-acre Hog Island. Work on the 1,600,000-kilowatt Surry Power Station started in 1966. The 840-acre plant has two pressurized water reactors, which went on line in 1972 and 1973. Surry Power Station, owned by Dominion Virginia Power, draws its cooling water from the James River. The rest of Hog Island is a wildlife refuge.

Richard Kingsmill owned this land, across the river from Hog Island, in the 17th century. Around 1635, Col. Lewis Burwell III founded a 1,400-acre estate here. It included a mansion and outbuildings (still existing, shown here). Quarterpath Road, parts of which still exist, connected Burwell's Landing at Kingsmill with Williamsburg. In the 1970s, Anheuser-Busch Inc. purchased the property and built Kingsmill on the James, a planned residential and resort community; Busch Gardens: The Old Country (now Busch Gardens Williamsburg) theme park; and a large brewery on it. (Courtesy of the Library of Congress.)

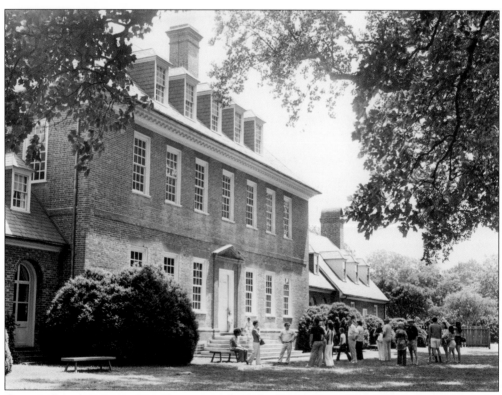

Carter's Grove, in James City County, was built for Carter Burwell in 1755. It was built on the site of Martin's Hundred, which was settled around 1620. Wolstenholme Towne, settled in the early 1600s, was discovered there in 1976. The home's last owners, Archibald and Mollie McCrae, restored and enlarged it in the 1920s. It has been called "the most beautiful house in America." Mrs. McCrae died in 1964, and Carter's Grove passed to Colonial Williamsburg via a 1969 gift from the Rockefeller Foundation. It was sold to a private owner in 2007, then bought back by Colonial Williamsburg, and sold again in 2014. (Courtesy of the Daily Press, Inc.)

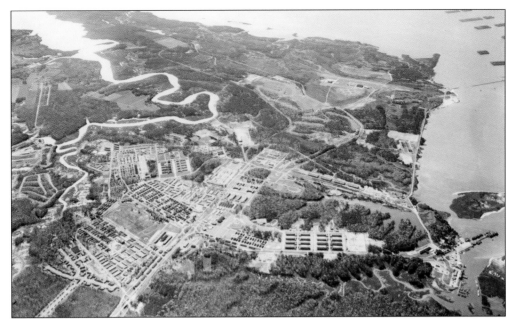

In 1918, the federal government purchased rural Mulberry Island, between the James and Warwick Rivers, and named it Camp Abraham Eustis. Renamed Fort Eustis in 1923, it housed artillery and infantry units, including the Coast Artillery School. During Prohibition, it was a federal prison. In 1946, the US Army Transportation School was moved there. Base Realignment and Closure (BRAC) caused the transportation school to move to Fort Lee in 2010. Fort Eustis and Langley Air Force Base merged to become Joint Base Langley-Eustis in that year. (Courtesy of the Daily Press, Inc.)

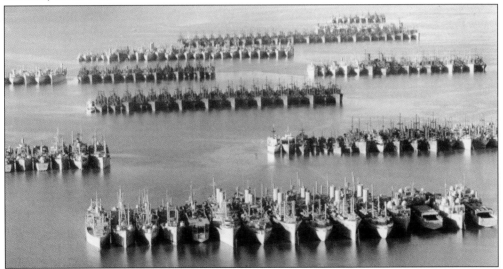

Adjacent to Mulberry Island, a portion of the US Maritime Administration's National Defense Reserve Fleet (NDRF) is anchored as the James River Reserve Fleet. After World Wars I and II, there were hundreds of ships moored here and as far upriver as Clermont; incredibly, they numbered over 800 in the late 1940s. Since around 2000, many of the ships, some dating back to the World War II era, have been removed under contracts with scrapping companies. In 2015, only nine remained. (Courtesy of the Daily Press, Inc.)

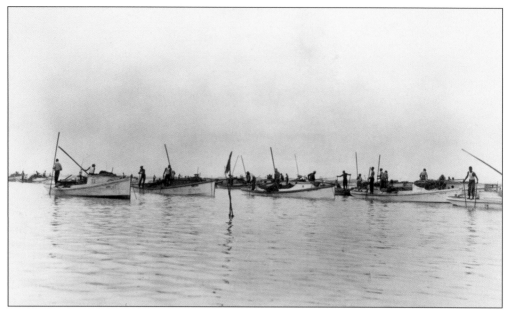

The old method of harvesting oysters by tonging is shown in this 1960 view on the lower James River. Modern oystering is done with power vessels and dredges. An abundance of oysters, other shellfish, and fish fed the natives and post-1607 settlers. Until the 1950s, oysters were plentiful in Virginian waters, but then oyster beds suffered severe damage from a disease known as MSX. Today, only spat (young) oysters are fished in the James at Newport News, and they are moved to more productive areas for maturation and harvest. (Courtesy of the Daily Press, Inc.)

Burwell Bay (pronounced "burl") is a wide expanse of water below Hog Island. Here, the James River is at its widest (5.6 miles). Five miles upriver, the water is 88 feet deep at Deep Water Shoals. The bay gets it name for the Burwells, who owned many acres on its shores. In the 20th century, Burwell Bay was a favorite resort and summer vacation spot. However, a storm surge from hurricane Isabel in 2003 destroyed cottages, piers, and the beach. (Courtesy of the Daily Press, Inc.)

The first James River Bridge, shown here, was completed in 1928. At 4.5 miles long, it was then the longest bridge over water in the world. A two-lane vertical lift drawbridge, it immediately connected the people on the north and south sides of the river. The passenger and mail boats from Smithfield and Crittenden to Newport News were put out of business. (Courtesy of the Daily Press, Inc.)

From 1975 to 1982, the original two-lane bridge was replaced with a wider four-lane bridge that could handle increased traffic volumes. It also featured a higher and wider lift span to accommodate larger, modern vessels, as seen passing under the raised lift span in this image. In 2005, the bridge carried an average of about 30,000 vehicles per day. The second bridge was built in phases so as not to affect traffic during its construction. It is the longest bridge operated by the Virginia Department of Transportation. (Courtesy of the Daily Press, Inc.)

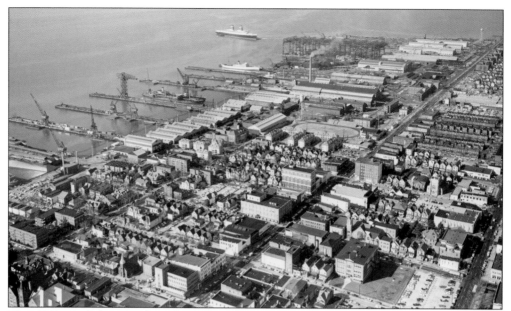

This 1962 aerial photograph, with a view looking west, shows downtown Newport News and the shipyard in detail. The main artery, Washington Avenue, runs diagonally upward to the right. In the background, the famous ocean liner SS *United States* is backing out of a dry dock after its annual overhaul that year. (Courtesy of the Daily Press, Inc.)

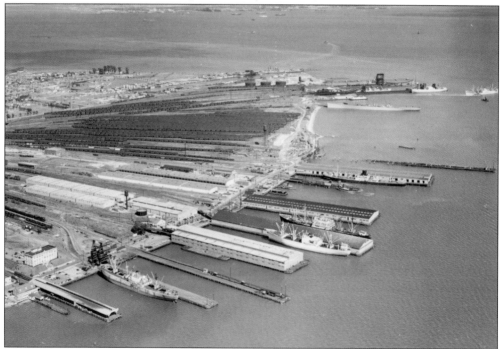

In this 1950s photograph with a view looking downriver, more of the city's waterfront is shown. The C&O passenger depot and pier are in the lower left corner and its cargo piers are in the center of the image. The coal piers are further down. Newport News Point is at the mouth of the James River. (Courtesy of the Daily Press, Inc.)

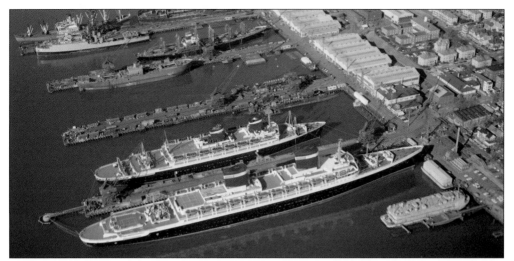

Newport News–built ocean liners SS *United States* (foreground) and SS *America* are shown on the Newport News Shipbuilding waterfront in January 1963. From its founding in 1886, the Newport News Shipbuilding and Dry Dock Co. quickly became a major builder of ships for the Navy and for commercial customers. Over 500 ships, many of them world-famous, have been built there and an additional 243 merchant vessels were mass-produced during World War II by a subsidiary, North Carolina Shipbuilding. (Courtesy of Huntington Ingalls Industries, Inc.)

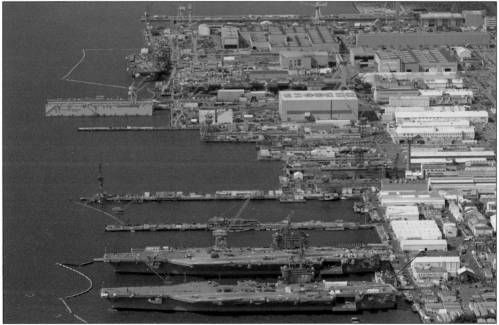

In September 2010, nuclear-powered aircraft carriers (pictured from bottom to top) *George H.W. Bush*, *Carl Vinson*, *Theodore Roosevelt* (in Shipway 11), and *Enterprise* were all at Newport News Shipbuilding at the same time. All 13 US carriers since the *Enterprise* in 1961 have been built at Newport News, and the *Gerald R. Ford* and new *John F. Kennedy* are currently under construction. Newport News Shipbuilding, now a major component of Huntington Ingalls Industries, is Virginia's largest industrial employer, building nuclear-powered Ford-class carriers and Virginia-class attack submarines. (Courtesy of Huntington Ingalls Industries, Inc.)

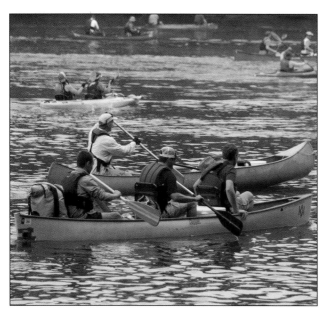

The James River Association was formed in 1976 as a voice for the river and the people who care about it. The health of the river has been improved thanks to the work of the association, along with other organizations, agencies, and individuals. The James is now consistently graded as one of the healthier major tributaries of the Chesapeake Bay, and the river is a major recreation and tourist draw for the communities along it. Riverfront parks are full of swimmers, boats, canoes, kayaks, and tubers in season. (Courtesy of the James River Association.)

On June 22, 2015, a wedding took place aboard the batteau *Clifton Lee* under the Wingina Bridge. It was the third day of the 30th annual James River Batteau Festival. Capt. Lisa Barbieri and Paddy O'Sullivan tied the knot and continued down the river the next day. (Courtesy of Capt. Lisa O'Sullivan.)

Six

MAPS OF THE JAMES

This key map shows the location of the James River's 10,432-square-mile watershed. The maps on the following pages were derived from a detailed map created for Envision the James. In 2011, the James River Association, Chesapeake Conservancy, and National Geographic Society launched Envision the James to inspire new and enrich existing community conservation efforts on the James River through education, exploration and community engagement. This is a collaborative initiative that invites communities and individuals to create a common vision for the James River to benefit present and future generations. (Courtesy of National Geographic Maps.)

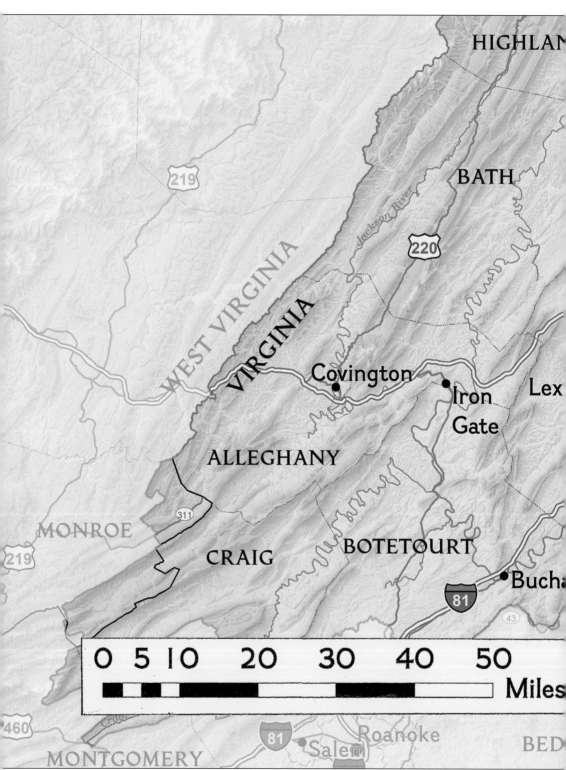

This map shows the river from its sources into Scottsville. (Courtesy of National Geographic Maps.)

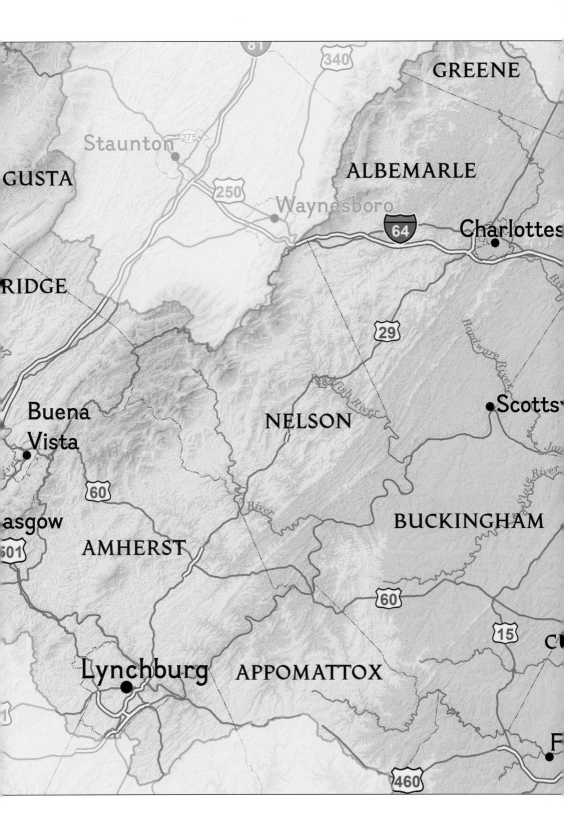

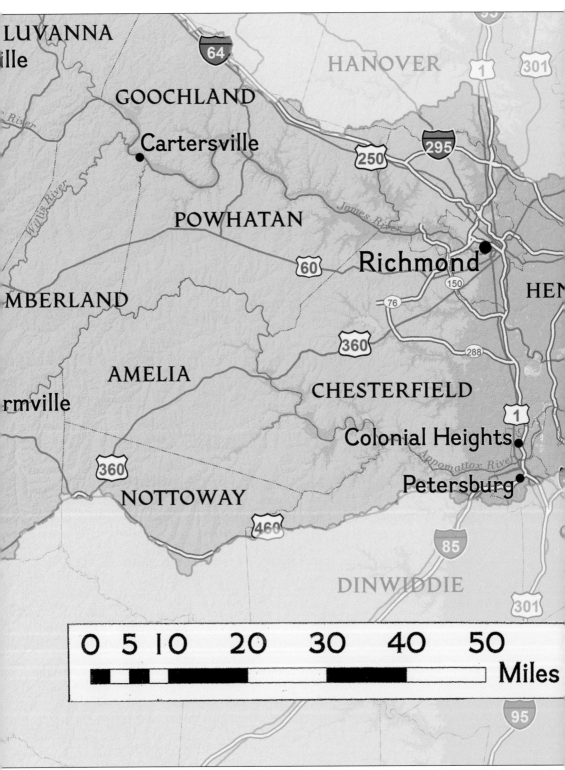

This map shows the James River from Scottsville to Newport News. (Courtesy of National

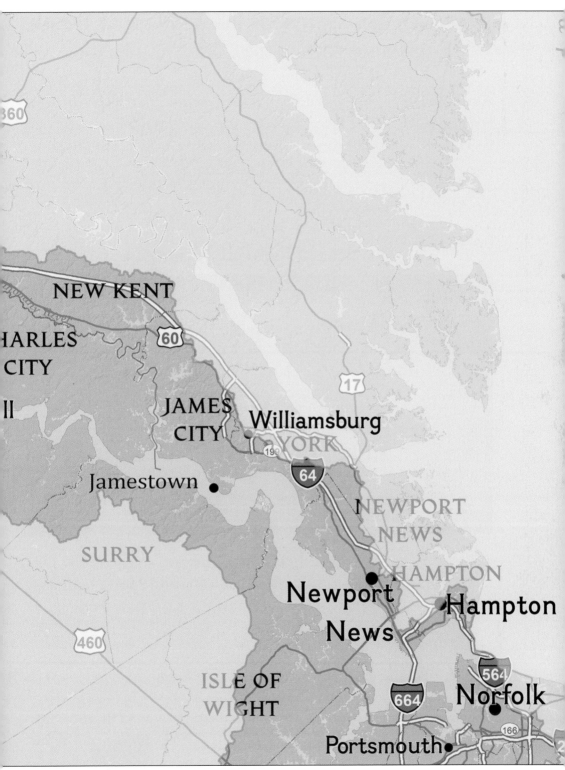

NEW KENT

HARLES
CITY

60

JAMES
CITY

Williamsburg

Jamestown •

YORK

199

64

NEWPORT
NEWS

SURRY

HAMPTON

Newport
News

Hampton

460

ISLE OF
WIGHT

564

664

Norfolk

166

Portsmouth •

Geographic Maps.)

DISCOVER THOUSANDS OF LOCAL HISTORY BOOKS
FEATURING MILLIONS OF VINTAGE IMAGES

Arcadia Publishing, the leading local history publisher in the United States, is committed to making history accessible and meaningful through publishing books that celebrate and preserve the heritage of America's people and places.

Find more books like this at
www.arcadiapublishing.com

Search for your hometown history, your old stomping grounds, and even your favorite sports team.